SECRET CRAWLEY & GATWICK

Tina Brown

AMBERLEY

To Andy Mellington and Rebecca Spencer from Queen Victoria Hospital, East Grinstead. Words can never thank you enough.

First published 2019

Amberley Publishing
The Hill, Stroud
Gloucestershire, GL5 4EP

www.amberley-books.com

Copyright © Tina Brown, 2019

The right of Tina Brown to be identified as the Author
of this work has been asserted in accordance with the
Copyrights, Designs and Patents Act 1988.

ISBN 978 1 4456 8567 0 (print)
ISBN 978 1 4456 8568 7 (ebook)

British Library Cataloguing in Publication Data.
A catalogue record for this book is available from the
British Library.

Origination by Amberley Publishing.
Printed in Great Britain.

Contents

Introduction

The definition of the word 'secret' is something unknown or hidden, a skeleton in the cupboard, something that was once commonly known but is now an intriguing piece of information. It is a mystery or something undercover or underground that few know about. With that in mind welcome to *Secret Gatwick and Crawley* and to a journey to discover the lesser-known people, places and events that have helped shape this area into what we know today. You may be surprised by some of the history – I certainly was and continue to be intrigued about the wonderful history of the hugely busy airport at Gatwick. Have you ever wondered what secrets are on your doorstep that you were never aware of, and how many times have you said, 'Well I never knew that' when told about a forgotten snippet of history. I hope that by reading this book you will learn a few things about this area that you would never have known and maybe it will inspire you to find out more and discover new secrets for yourself.

I have always had a curious and enquiring nature, fascinated by a building's history and how its past has shaped what we see today. Today Gatwick Airport and the businesses connected with it employs roughly 21,000 people, contributing £2 billion to the London and surrounding community, and each day 213,000 passengers land or depart here (approximately 78 million people a year!). Out of all those people has anyone ever stopped to think about what was there before the airport – maybe some people think it has always been an airport and cannot imagine the area as being anything else. Well step back in time with me and I can show you the glamour of a time when the airport was Gatwick Racecourse, the only other racecourse to run the Grand National.

A town in West Sussex closely linked with Gatwick is Crawley (6 miles away), which has an approximate population of 110,000. The motto of the town is 'I Grow and I Rejoice'. Many visitors and even residents of Crawley today would be wrong in thinking that the whole of the town is modern as the town was founded in the fifth century and has a fascinating past. Crawley today has 104 listed buildings, meaning that there are numerous buildings of special architectural or historic interest in the town, including churches, old inns and farmhouses but also a mill, signal box and the Beehive. The new town of Crawley, as its known today, is a little over seventy years old, being one of eight new town locations around London. In this book I will share with you some of the secrets of these buildings that you may have walked passed numerous times.

Between these two areas there are many rural villages where historic churches and glimpses of the past can still be seen for those who venture from the main path. This book will introduce the reader to secrets from this intriguing area, lesser-known historical facts that bring to life the town's past and past famous residents.

The area is simply steeped in fascinating history, offering contrasts between the ancient villages located a few miles from Crawley and Gatwick and the modern-day busy airport and town centre of Crawley and the industry of today.

Every year through my work I am told snippets of historical information and carry out extensive research into an area's past to include in my writing projects. I hope you will find this ensemble of tales interesting and perhaps a little mysterious too. Above all it is hoped that after reading about the secrets this area has to offer, you will look at the area in a different light. Look beyond the obvious and ask questions, and you will most certainly be rewarded.

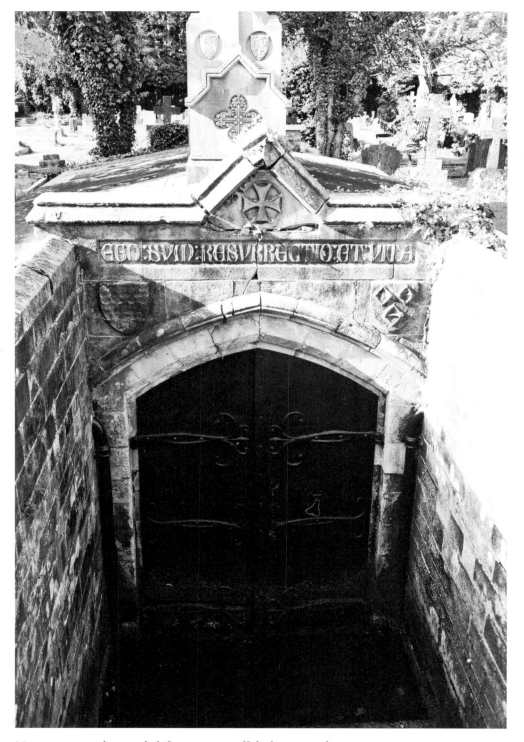

Many secrets can be revealed if you venture off the beaten track.

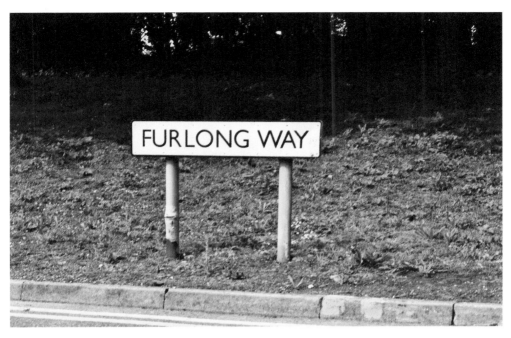

Furlong Way. Little remains of the airport's former life.

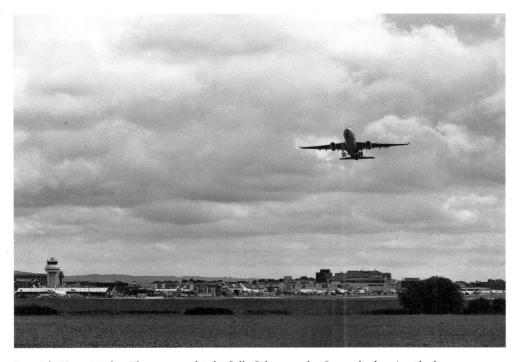

Gatwick Airport today. The area used to be full of the sounds of crowds cheering the horses.

Secrets will be revealed to those who visit the Franciscan monastery.

1. Ancient Settlers of the Crawley Area

Its easy for the passer-by or the fleeting visitor to think that Crawley has always looked like it does today and that it has no history beyond the middle of the twentieth century. They are very wrong. The area has a rich history from the Bronze Age and beyond, and there's evidence to suggest that the Saxons arrived in the South Downs as early as the 470s and settled within the dense forest areas around Crawley. As the settlements increased in number and more people moved to the area large clearances of the forest took place to make way for pasture for their grazing animals and timber for construction of their buildings. One of the remarkable Saxon buildings is that of Worth Church, Ifield. There have also been burial mounds found in the area.

There is an extraordinary item on display at Crawley Museum and this is a Bronze Age sword, found in Polesfleet Stream during drainage works in 1952. The sword is in excellent condition and probably is linked to the ancient tradition of throwing precious objects into water to ask the gods for their help and assistance during times of need, especially during crop harvesting seasons. There has also been evidence of when the Romans arrived at the beginning of the first century, with traces of over a hundred furnaces throughout the area.

Over the years there have been many archaeological surveys and evaluations carried out in the area used to develop Gatwick Airport, as is the case with all developments. In February 2001, lasting for approximately four weeks, an archaeological evaluation took place that was a mixture of machine trenching and hand-dug pits, which was proposed to be used for construction in the area. The reason for this was to examine the natural soil sequence, which was made up of Weald clay, terrace gravels and alluvium. There was also a further test pit excavated to establish the possibility of prehistoric lithic scatters being present in the soil environment. This was an exciting project. Several pits could confirm the presence of Weald clay, which was established over the whole site. There were also the discoveries of post-medieval artefacts in the form of material used for buildings, pottery, blast furnace waste material and a single piece of prehistoric flint. There were also two small sherds of organic pottery found dated to the early-middle Saxon period. This find, together with small samples of charred plant remains, is evidence supporting settlement activity.

Gatwick Airport itself is located on the northern edge of the Weald and lies within a wide valley created where the River Mole and other tributaries flow off the Weald and run towards the River Thames. The area has always been of high archaeological interest and potential, with evidence of human activity and settlement in the area from the Mesolithic through to the medieval period. The land around this area combined with the alluvial deposits would have helped to preserve organic materials such as wood and bone.

There were several small sherds of early-middle Saxon pottery recovered, plus quantities of charcoal were noted.

Finding the charcoal points to human activity in the vicinity. However, with the lack of any cereal and plant remains this could mean that there was no domestic activity within the immediate excavated area. However, the evidence of the charcoal being present could help identify whether there was domestic activity in the area, simply by the species of the wood and whether it would have been suitable to be used for domestic burning. This may also point to evidence of the nature and management of the local woods.

The evaluation concluded that the earliest human activity would have been, based on the single worked flint blade, from around the Mesolithic period. This was found under medieval and later soil deposits. There was also the presence of a gully, which contained deposits of pottery and charcoal, could suggest that a Saxon settlement was located close by, if not in the given area.

So again, by learning of these archaeological findings in what is now Gatwick Airport it makes us feel closer to the past, that we are not the first people to use this area but just one in a long line of settlers who have found this area suitable for their needs, whether that be domestic or commercial. Many items of archaeological significance have been found in the area including a medieval book fitting found at Crabbet Park Worth, a Georgian shoe buckle and a medieval horse brass.

2. Gatwick Before the Airport

The name Gatwick is derived from when the woodland was being cleared and since early times the area has held many secrets. In one corner of the airport grounds on the east side of Lowfield Heath Road, Charlwood, you can find connections to the Second World War. In a wooded area that backs onto the airport there are sunken air-raid shelters. During the Second World War the RAF took control of the airport, becoming RAF Gatwick. These shelters date from that period. The shelter is constructed from brick with a concrete roof. Sadly, the wooden roof beams have rotted and fell away long ago.

A lady from the Gatwick and Crawley area shared the following story with me about her own family connection to the airport:

During World War Two my family were living at Toovies Farm, in the Balcombe Road, which is still there today. My grandad was working on the farm, whilst my mum and aunt cycled to Gatwick Airport to work. Mums' work was sewing the wings of the Tiger Moth planes. These planes were small and used for training purposes at the airport. After the wings had been sewn, the planes were sent to the 'doping shop', a messy and smelly job painting the wings to strengthen and waterproof them. One day mum described how everyone rushed outside with excitement because a massive Blenheim Bomber had landed for refuelling. They were all totally stunned to see such a giant next to the little Tiger Moths! Mum was fascinated by the planes and the concept of flying and plucked up courage one day to ask if it would be possible for her to have a ride: in a Tiger Moth – and she did! All her workmates thought she was mad, no one flew them, only pilots, and certainly not a woman, and flying was still a pretty scat thing to do in the 1930s and 1940s. However, Mum climbed aboard, wearing her ordinary day coat, and off she went. She said it was freezing but absolutely loved the experience.

Many years on we treated Mum to another Tiger Moth flight when she was eighty-one years old. I drove her to Redhill aerodrome, where we met up with my son and my sister. Mum had no idea what was going to happen, but she did notice the Tiger Moth in the distance, so I asked her if she fancied 'having a ride'. She replied with no hesitation, 'Ooh yes please!'. So, Mum was kitted out in a large sheepskin jacket and crash helmet. I had bought her gloves and a blanket for her knees, so she was considerably warmer this time. Mum thoroughly enjoyed her second flight, and we had a DVD made of the whole trip. I think she enjoyed chatting about her wartime adventure with the planes and the Tiger moths' owner, and apparently, they still so sew the wings and dope them afterwards!

As told to me by Heather Ashby (née Revell), Horsham

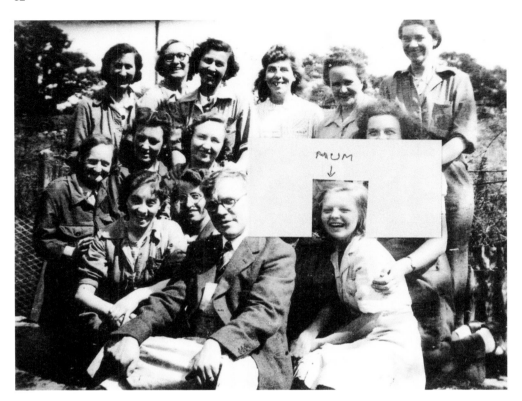

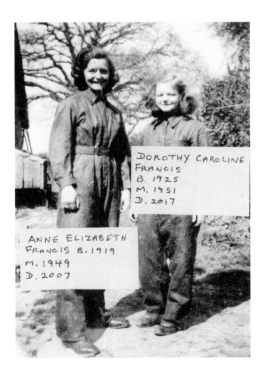

Another fascinating story told to me has more of a ghostly nature attached to it, many believing that the souls of many people linger on at the airport today as it has, for many years, been an area associated with gatherings or large numbers of people, whether it be excited and bustling groups of people attending the horse race meetings or family and friends saying goodbye to one another or welcoming travellers home. The airport has seen its fair share of emotions and some of these must have lingered on in some way. Many employees at the airport and residents close by have told of strange phenomena and activity at the airport, which they have not been able to identify or say exactly what they have witnessed. One ex-office worker remembers seeing strange things on a night when they were leaving the building and the airport was very quiet. He reported seeing a gentleman in old-fashioned RAF uniform walking through part of the terminal and out through the wall. He was so shocked at seeing this figure he didn't know what to do! He remembered as much detail as he could and it was as if the gentleman looked straight at him and acknowledged him. He walked through the wall in the direction of where, during the Second World War, planes and buildings were located. The next day he mentioned what he had seen to some of his fellow workers and they too had seen the figure. Apparently, this is the ghost of an officer who was based here during the Second World War and was very proud of his position and his job. He ran the base very professionally and was known for his work, which was of the highest standard. Legend says that he has returned in spirit form just to ensure that today's employees are working to the same exacting standard that he expected at the RAF airport. Several photographs have been taken by the public over the years in the airport and several have mentioned the significant appearance of orbs in many of them. Other strange things have been reported over the years. Sounds of plane propeller engines starting up have often been heard but no planes of that sort have been seen. Also, there have been several reports of thick and swirling mists appearing suddenly as if from nowhere accompanied by an intense drop in temperature, sweeping through the building and then apparently stopping as quickly as they started. No one knows what these are but they have been occurred several times a year in recent times.

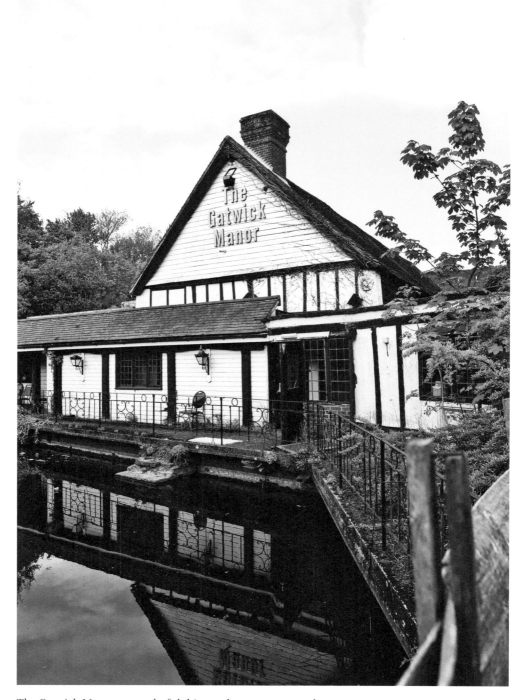

The Gatwick Manor, a wonderful thirteenth-century manor house.

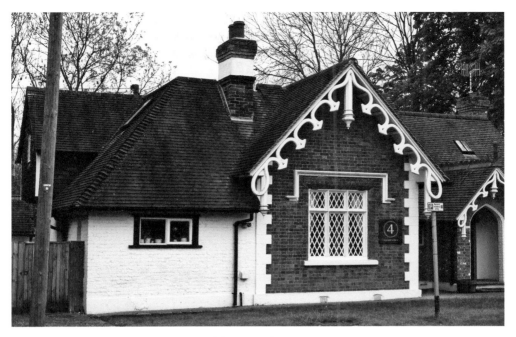

Gatwick manor lodge house, once part of the Gatwick estate.

Racecourse Way, a reminder of the airport's secret history.

3. The Iron Industry

Tinsley Green is an area in the north-east of Crawley. The name was first recorded in the thirteenth century when Richard de Tyntesle (Richard of Tinsley) was recorded on official documentation. The area prospered from the iron industry from the late fifteenth century when the blast furnace was developed. The conditions and access to the raw materials around Crawley were perfect to produce iron, which resulted in many forges being set up. Tinsely Forge was one of them. Cast iron was produced at a blast furnace at Tilgate and taken to Tinsley Green where it was worked and turned into wrought iron. The industry suffered a downturn in the seventeenth century but continued well into the eighteenth century when it was finally closed. There were still many local places with names connected to the iron industry; for example, Forge Farm was established on the old site and Black Corner on the old route to London, which runs through Tinsley Green, refers to the old industry. It is hard to imagine this part of the countryside being a major contributor to the iron industry in the country. However, the raw materials available here meant that iron could be smelted for over 2000 years. The woodlands and forests were ideal for the construction of the furnaces and producing charcoal for fuel. The numerous small streams and waterways provided the supply of water to power the bellows.

During the first two years of Roman occupation and then also during the Tudor and Stuart era this part of the Weald was the main area for producing iron in the country. When the Romans invaded, they discovered that there was a long-established iron-producing industry, which benefited from the need to build villas, towns and farms. However, it was during the Middle Ages that the iron industry really grew and prospered, and there is documented evidence of an increase in trade in the Horsham and Crawley areas. It was during the end of this period that waterpower was taking off and was used for forging iron, which saw the introduction of the blast furnace in 1496. This idea came from France and was much larger than the bloomery, which had been used up until this period. Now the daily output could be more than a ton instead of the previous few kilos that was produced. Skilled migrants also worked the furnaces. During the sixteenth century there were around fifty furnaces and forges in the area and this number doubled over the following twenty-five years. All over this area of Weald the industry was significantly contributing to the lives of many people, with thousands being employed in the trade either in the form of digging, cutting or transporting raw materials or finished products. It is hard to think how large this industry was and how dominant it was in the Crawley Weald area, something which is seldom thought about today. These beginning would have contributed to the success of the area today; without it things would have been very different.

Today you can still find evidence of this trade in some farmhouses and churches, which contain decorative plates relating to the industry that once thrived here. Churches also have examples of iron memorials on display. Moving into the early 1800s the demand for more

and more iron increased and therefore buyers looked further afield for larger quantities. You may wonder where the remains of this industry are and what can be seen today. Sadly little remains intact as the building materials would have been reused due to their value and the works were dismantled. Today much woodland will have grown over the original sites, meaning that little can be seen, but the secrets are still there for those willing to discover them.

The Dragon inn at Colgate also has a connection to the old iron industry in this corner of the Weald. Colgate village lies in the heart of the St Leonard's Forest and is an Area of Outstanding Natural Beauty. Forest Road, which runs through the parish, follows an old track that would have connected the Ashdown Forest with the Adur Valley.

There are archaeological finds from work at Broadfield showing evidence of the Iron Age activity in this area.

DID YOU KNOW?
Crawley was perfect for the iron production due to its geographical location.

The landscape of this area changed dramatically when the blast furnace was introduced, the first one being in 1490, transforming the Wealden iron industry. A blast furnace was a step up from the clay pot bloomery as it was able to provide a continuous supply of liquid iron. It was constructed as a hollow brick-built tower with iron ore and charcoal put into the top and molten iron tapped out at the bottom. It also had a continuous supply of air from large bellows. If any of the three ingredients failed, then that would have been the end of the furnace's production. The ironmasters of the area had to carefully plan the continuous supply of these. There were two of these furnaces at Worth Furnace, in the present Worth Forest, constructed by William Leavitt in 1547. The furnace bellows were powered by a watermill. You also needed the supply of charcoal, which was a delicate substance, to move a great distance and so local sources had to be found. Recent archaeological evidence has suggested that there were two charcoal oven platforms in the forest. The area known today as Furnace Plain at the golf course was one such coppice in the forest providing wood for this industry.

DID YOU KNOW?
Many local inns and churches have connections with the iron industry.

4. Smuggling Secrets

Every coastal town and village has some connections to smugglers and this also extends to some inland areas where accessibility along estuaries and perfect hiding places in wooded areas are in strong supply. If you delve deep enough there are fascinating stories connected to the smuggling trade of this corner of south-east England. With Crawley's ideal location between London and the coast and dense forestland, this was the perfect hiding place for smuggled items and illicit goods. Woods in this area around Copthorne and Crawley Down were used by smugglers to hide their goods and sometimes even the perpetrator themselves.

There is one intriguing little cottage known as 'The Smugglers Cottage', which can be found along Copthorne Road – the A264 was an ancient route from East Grinstead to Crawley. The cottage is said to date from medieval times and is a wonderful example of the traditional materials wattle and daub and leaded light windows. Today the property is Grade II listed and stands in 2/3 of an acre of land on the northern edge of Copthorne Common.

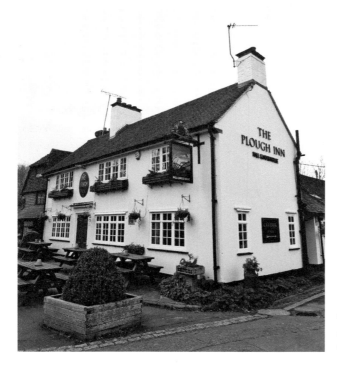

The Plough Inn, Ifield, is one of the many pubs connected with smugglers.

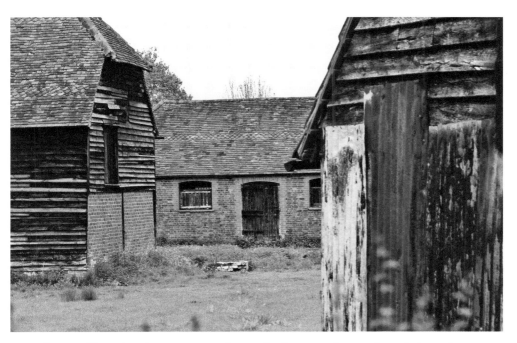

Smugglers would say that these areas were haunted to keep people away from their goods.

For centuries the cottage was simply known as 'The Cottage' and it wasn't until 1932 that the name 'Smugglers Cottage' came into use. Many people have described the house as suitable for elves and pixies due to its quaint stature and perfect location. The house has been attached to the smuggling gangs for centuries. One notorious gang were from close to Nutley, who would bring the contraband goods by barge from the sea up to the River Ouse and then on to houses such as the Smugglers Cottage and deep into the dense forest land close by.

One famous smuggling character was a gentleman known as the 'King' Colin Godman or Goodman, who was not someone that could ever be traced, so whether this was his real name is uncertain. Many smugglers took on false names or changed their name slightly to evade being caught and prosecuted. It was believed that Colin was murdered and buried in a cellar room beneath the dining room of an ancient house in Nutley, which later took his name. He is, however, said to also haunt this house as it is rumoured that some smuggled goods buried here were never recovered. His ghost guards them so that no prying people can come and take what is his! So, beware if you are wandering around these parts.

DID YOU KNOW?
Smugglers were known as 'Owlers' due to the sound that was made by them to let one another know the coast was clear.

Smuggling secrets surround Charlwood Farm – who knows who lies in wait! Not a place to walk after dark.

Gallows Woods got it name from another member of a smuggling gang, who was hanged here for betraying a fellow member of the gang.

Gangs during the height of the smuggling era (1700–1840) were experts in the trade and would bring lace, silks, tobacco, brandy and other exotic items ashore on the south-east coast, with one third of the tea and one half of the gin consumed in England being from smuggled goods. Gangs in the Crawley area were ideally placed, given their proximity, to sell the goods in the city of London. The area of Snowhill saw an increase in the smuggling trade and it was estimated that nearly every family in the area had some connection with the illicit activities.

A system was used to alert locals that goods were approaching in the form of a watchtower and light. A series of flashlights was used, each with their own meaning. However these did not always work well as rival smuggling gangs would often trick one another, which resulted in prosecution and hanging. It was clearly a cut-throat business as much money was at stake. It was estimated that one half of England's overseas trade was through smuggling and it employed around 40,000 people.

Some smugglers involved their whole family in the work, with the women stitching goods into their long skirts and the children often acting as decoys to avert contraband guards from stopping the activities. Many cottages in the area had deep cellars where much of the goods were hidden – some even used local graveyards and churches as hiding places.

St Leonard's Forest, part of the High Weald, was another popular location for hiding smuggled goods during the seventeenth and eighteenth centuries. A story published in a London newspaper around 1614 told of a terrifying dragon that lived in these woods and some individuals had reported seeing the beast and ran for their lives. Stories and tales like this were often created by the smuggling gangs to keep people away from the areas used by them to store and hide their goods and it seemed to work.

Many local inns were also used by the smuggling gangs for meetings and for hiding goods. One of these was the George Inn, which is now known as the Ramada Crawley Gatwick in Crawley.

5. Notable Residents

Crawley has had its fair share of notable residents, some famous and well heard of and others not so. This chapter tells their stories, some of which are individuals and others are groups whose story should be heard and remembered.

Crawley has many past literary connections. Many of the buildings have strong links and these include the Punchbowl, Bar Med, Jubilee Oak, Brewery Shades, White Hart, Ancient Priors and a shop in the High Street dating from the sixteenth century. These buildings will be further explored in another chapter, but the writers connected with them are detailed below.

Writers

Francis Thompson (1859–1907) resided at No. 11 Victoria Road, Crawley, during 1905–06. He was a poet and essayist, with his most famous poem being 'The Hound of Heaven'. He is also well known for being a possible suspect in the Jack the Ripper cases.

Frederick Knott (1916–2002) is commemorated by a plaque on the wall of the Mason Centre, and was the writer of *Dial M for Murder*, which he penned at his parents' house Little Balgair, which is sadly now demolished, once stood in Langley Lane. *Dial M For Murder* was shown on television, in theatres in London and Broadway and was also turned into a film by Alfred Hitchcock in 1954.

The Friary Cemetery is where Lord Alfred Douglas (1870–1945) is buried. He was known as 'Bosie' and was a great companion of Oscar Wilde. Bosie was a poet and wrote the line 'I am the Love that dare not speak its name'.

Mark Lemon (1809–70) is well known for being the first editor of *Punch* magazine. Mark dined at the George Inn with contributors to the magazine to plan future editions, one of whom was Charles Dickens, whose stories Lemon dramatised. He lived at the top of the High Street in a house known as Vine Cottage, which is now the site of a restaurant. His youngest daughter, Kate, at the age of eight was the model for Lewis Carroll's book *Alice's Adventures in Wonderland*.

Una Pope-Hennessey (1876–1949), who is buried in The Friary Cemetery, was a biographer, most notably for Charles Dickens, Charles Kingsley and Edgar Allan Poe.

John Leech (1817–64) was one of the contributors to *Punch* magazine. When he was a medical student he lived at the bottom end of the High Street in the house known as The Tree, and from 1843 to 1848 he illustrated the Christmas stories written by Dickens.

One of Sir Arthur Conan Doyle's mystery stories *Rodney Stone*, written in 1896, has connections to the George Inn, or Ramada Crawley Gatwick as it is now known. The location was central to the plot of this Gothic mystery book, which also centres around prize boxing in Regency England.

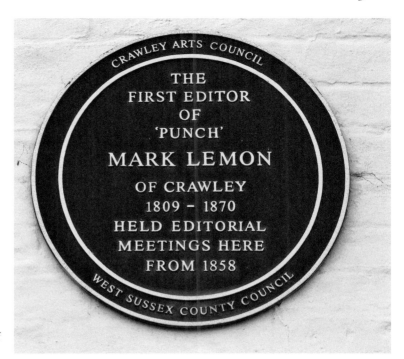

Mark Lemon's blue plaque on The George Hotel, which is linked with Sir Arthur Conan Doyle and is where one of his stories was based.

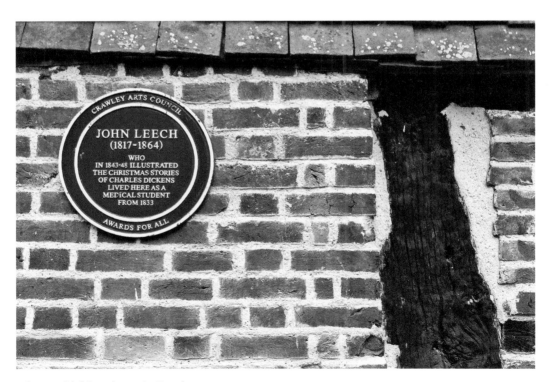

John Leech's blue plaque in Crawley.

The Black Dog was built in the 1950s as a community pub.

Irish playwright, novelist and story teller Brendon Behan (1923–64) used to frequent the Black Dog pub in Crawley. He was widely regarded as one of the greatest Irish writers of all time. His works included *The Hostage, Borstal Boy* and *The Quare Fellow*.

Blunden Shadbolt (1879–1949)

Born in London in 1879, Blunden Shadbolt moved his family to Horley in 1898. He was known as an architect and designer and completed his training with George A. Hall in Victoria Street, London.

He designed timber-framed buildings that were made to look as though they were ancient and incorporated many of the features that had been seen in these old properties that people loved. Typical features present in his designs were minstrel's galleries, massive chimneys and inglenook fireplaces. He liked his houses to be natural and not to feature straight lines in his constructions; he wanted his houses to be in harmony with the surrounding trees and took great care to preserve and look after nature with his designs.

He displayed designs of his work at the Ideal Home Exhibition in 1924 and 1926 and this helped him gain admiration and customers. He went on to construct houses in Copthorne, Kingston and Crawley to name but a few locations in the UK.

Following the end of the Second World War he assisted local authorities in the repair of numerous bomb-damaged buildings and to rebuild the country. He sadly passed away, at the age of seventy, in 1949 following a road traffic accident. However, many of his designs remain today, which show the magnificent creativity he had.

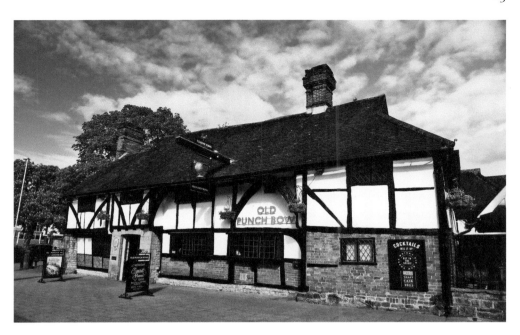

Above: The Old Punch Bowl is a magnificent medieval timber-framed Wealden hall house on the High Street of Crawley.

Right: The Old Punch Bowl was built in the fifteenth century and was used as a farmhouse until 1600.

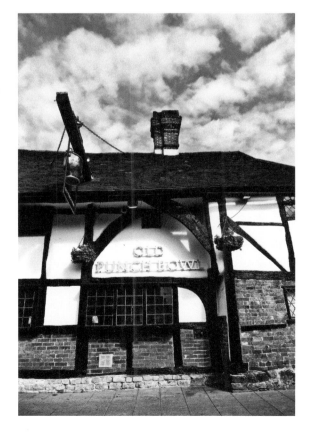

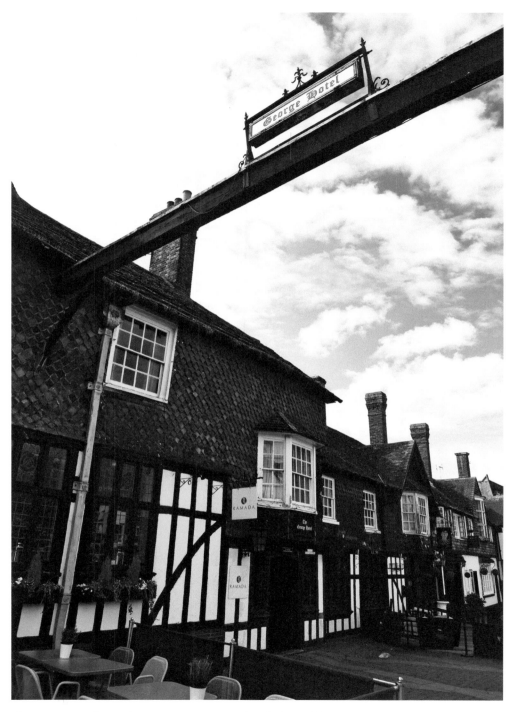

The George Hotel, Crawley, was once connected with the acid bath murderer as this is where he frequented.

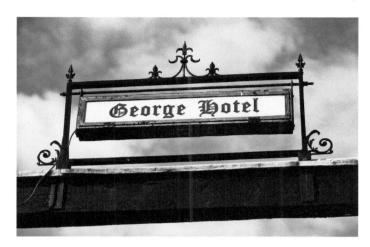

Sign of the George Hotel, High Street.

Dame Caroline Haslett

I would have loved to have met this fascinating lady. She was born in Three Bridges in 1895 and joined the suffragette movement in 1913. This was without the blessing of her parents as they were not very supportive of her activities, but Caroline was a strong lady and knew her own mind. At one of her meetings she sat next to Emmeline Pankhurst and the two had a heated discussion. Caroline spent most of her career as an electrical engineer. She was forefront in improving the roles of women in the workplace and was a member of various committees and organisations. She was made a Dame in 1947 and in honour of her life Haslett Avenue in Crawley was named after her. On a Three Bridges substation there is a blue plaque to commemorate her.

Sweeney Todd, the Barber of Fleet Street, London

Whether you believe in the stories about Sweeney Todd, the barber from Fleet Street in the city of London, is individual choice but one thing that you probably didn't know is that he has connections with numerous towns and villages throughout the South East – including Crawley. Sweeney Todd was born in Newgate in London in 1748 and he travelled to Hastings, East Sussex, via Crawley at the age of fourteen looking for work. The story goes that Sweeney stayed in Crawley and worked for an old butcher's shop in one of the side streets. It was here that he first learned the trade and mastered the use of knives. Sweeney was much liked and his employer in Crawley was sad to see him go, but Sweeney wanted to get to Hastings and to see the seaside. However, he promised that one day he would return to Crawley. Sweeney travelled to Hastings and again sought work, and was snapped up by a butcher's shop in the High Street called Harris The Butchers. Mr Harris was pleased to find a young chap as nice as Sweeney who was so keen to work. Sweeney Todd was pleased to find such a position and thought himself doubly lucky because Mr Harris had a young and beautiful daughter, whom Sweeney Todd planned to marry. After six months of employment, Sweeney plucked up the courage to propose to Miss Harris, but she turned him down. Sweeney did not expect a refusal and it changed him. He felt a terrible desire to slit Miss Harris's throat so that she could not tell anyone about his proposal.

One night, Sweeney Todd crept into the upstairs room of the butcher's shop and found Miss Harris doing some paperwork. She was all alone as her father had gone out for the evening. Sweeney took his chance and with one stroke of the knife, she was dead. He dragged her body downstairs, cut it up and, it is said, made her into sausages and pies to sell in the shop.

Sweeney Todd left Hastings in 1762 and returned to London. Sadly, he never made it back to Crawley as he was caught pickpocketing in London and sent to Newgate Gaol until he was nineteen. After his release, he set up a barber's shop in Fleet Street and the rest is history...

A Local Family's Story

The following is an account of one family from the Crawley area and the struggles they experienced. I am very grateful for Heather Ashby (née Revell) for sharing her family secrets with me.

On 18 January 1917 my grandparents married in St Nicholas' Church, Charlwood. My nana, Annie Caroline Reeves, came from Brighton originally, and was a maid in the 'big house' – Pagewood. Grandad Siney Alfred William Frances was a gardener. My uncle Sidney Alfred was born in 1918, followed in 1919 by my Aunt Anne Elizabeth. Then came Arthur in 1922, but sadly he died within a year. In 1924, Uncle Ernest Albert was born, and finally my mum Dorothy Caroline in 1925.

Life was hard for agricultural workers. They had to get used to packing up their lives and moving to wherever there was work. It must have been a huge operation because although they didn't have all the goods and chattels of modern life, it all had to be stowed into assorted carts and waggons pulled by horses and moved sometimes miles away.

Eventually the family ended up in Crawley, when it was little more than a village. They lived in a cottage in Cross Keys, near St John's Church, and the children went to the Council School in Robinson Road in 1928/1930s. They used to walk all the way to Tilgate Forest for a day out, which was a long way for children to manage, but pretty much everyone walked everywhere in those days.

When Mum was about four or five, my nan had to spend time in the Crawley Cottage Hospital, where she had to undergo a kidney removal. I imagine this must have been a very scary experience in the 1930s, and no doubt very costly (no NHS then – however did poor people manage?).

My nan was a very strict lady, belonging to the Salvation Army since its very early days. She was tough on her children; Mum told me she had 'misbehaved' one time, and although she was only three or four her mum had shut her in the darkness of the under stairs cupboard. Poor mum was terrified, but didn't dare come out until her beloved big sister Anne came home from school ... Anne let mum out and told her to run quick and hide in the garden. Then of course Anne had to endure the wrath of her mother for doing such a thing.

Much later on, it was wartime ... Mum was walking along a street when the air-raid siren went off. Everyone dived for cover, and Mum was grabbed by her arm and pulled into a pub for safety. Mum said she didn't know if she was more frightened of a bomb landing, or of her Salvationist mother finding out she had actually been inside a pub!

Sadly Mum and all her family are gone now. Mum was the last one who died aged 92 in 2017. We had grown up in Crawley, firstly Langley Green, then Pound Hill, then West Green, then Northgate, and finally we ended up in Furnace Lane in 1964, where I lived until I married. At that time most of Furnace Green was yet to be built – most of it was the Hawth Forest, complete with the charcoal burning industry until the land was all cleared for housing. We had a great time as youngsters there; Tilgate Forest was nearby, with a long winding stream to paddle in all the way up to Tilgate Lake. The forest had not been turned into a park then, and there was still the ruins of old boat houses, and the derelict mansion – a kid's paradise. The lake was pretty much hidden by all the shrubs, bushes and trees that surrounded it. We made camps and dens, collected frogspawn to watch the dots turn into commas and then tiny frogs, found tiny stickleback fish in the shallows of the stream, picked wild daffodils to take home to Mum.

The town centre hadn't been developed very much in the early '50s but I do remember the 'International' in the Broadwalk. It was the first supermarket in town I believe and as well as big shopping trolleys there were little ones for us kids which were brilliant. It took Mum awhile to get used to the consent of taking things off the shelves and putting them in her trolley. She said it felt like she was stealing.

Crawley town centre turned into a great place to visit: lots of different shops, a lovely Queens Square where everyone could meet, sit and chat whilst us kids hopped on the squares of the Chess Mosaic, or dabbled our hands in the lovely 'Boy and Dolphin' fountain. My dad took me and my sister to Lyons Buttery for a wonderful lime milkshake and a toasted teacake for a Saturday treat. We always dressed up to go into town, and polished our shoes especially for the occasion ... to this day the smell of shoe polish and Wrights coal tar soap remind me of my dear dad.

Of course, the town had its 'celebrities' there were two old chaps with an old dog who always walked one behind the other. I don't ever remember seeing them sitting down, or in a shop, just walking and walking and walking. Mum called them chickweed and groundsel for some reason! Eventually one died, but his brother kept walking and walking and walking, and then one day he was no longer seen.

I particularly liked the Queensway Store. It sold pretty much everything you could possibly want and I just loved going up and down on the moving staircase, a novelty in those days. Penfolds in the High Street had lovely smells of cornmeal, hay, straw and animal feed. There was another shop in the High Street which sold haberdashery, and all the cabinet, shelves, flooring were made of wood. Next to that shop was a posh shoe-shop, where my dad took me to buy my first pair of 'kitten heels' for our school disco ... I was 12 and so loved those shoes; cream coloured, slightly pointed toe, and a cream bow on top.

Crawley Women's Institute

The following report is from a meeting of the Crawley Women's Institute written in the *Sussex and Surry Courier* on Saturday 15 April 1944:

Crawley Women's Institute Letter from 'Adopted' Soldier

At the April meeting of Crawley WI held in the Congregational Hall on Tuesday at which Miss Benn presided, the following letter was read from the interned soldier 'adopted' by the Institute.

'Dear Mrs Ball – I was pleased to receive a letter from you and hoping this finds you all well, as this one leaves me. As a matter of fact the only thing most of us suffer from is boredom. But as you say it relieves us to get a letter now and again from home and I am very grateful. One thing about this life is that we have plenty of time to prepare entertainments etc. which we have every week. Some of our shows are very good and well worthy of a better place to perform them in. Still the object is a good one and that is the main thing. In my opinion in most cases the life here brings out the best in a man and he finds out things that he never thought of before. Will you please give my thanks to all members of the Institute for the parcels received, the contents of which exactly fill the bill also to Miss Benn for the trouble she is taking in making the slippers. The blanket will keep off colds as the nights are very cold. Best of luck.

People of all backgrounds and ages have made the Crawley area what it is today and I have found a great article in the Crawley and District Observer, 1944 which describes one remarkable gentleman who is part of the towns secret history.

Wayside Notes Peep into the Past.

Another link in the history of Crawley was broken by the death if Mr R W Tullett which occurred at East Grinstead last week. He was born in Crawley and as a lad lived in one of the squatters cottages in Smalls Lane. On leaving school he went into the cycle trade and later the motor works at Mr Ambrose Shaw of the Bay Tress, Crawley. From there he went to Imberhorne where he was a chauffer to the Blount family for nearly 40 years. His part in Crawley history was that he lived with his grandmother who it has been recorded was the last resident of Crawley to see the four horsed coaches come up Smalls Lane and go over Ifield Road or Lane as it was called then and go out to West Sussex. That being the only means of getting there by road unless you travelled over Pease Pottage Hill and out via Colgate Road. Mrs Tullett told her story to the late Dr T H Martin, who wrote down the old lady's notes. The deceased in his younger day was a fine gymnast. At the parish rooms there was a young men's institute and he and Bob Ireland were fine on the bars and rings. He was more than useful with the gloves. He was a firm supporter of John Penfold's "Rangers" the old "Black and Whites", He married into another old established family the Grantham-Hole family which has several centuries of Crawley history behind them.

In my research to uncover secrets about Crawley and Gatwick I have found some remarkable people who are well deserved on a mention in this book. There is one gentleman in particular who was written about in the Crawley Observer 1940:

In these days when savings are a national question and one of paramount importance, the founding of school banks is of much interest. It will be recalled that practically every elementary school ran its own Penny Bank. In the Crawley district the idea was started by the late Rev. Walter Loveband at Ifield School. Up to August 1891, children had to take two pence per week for payment of their schooling, however when then assembled after the school holiday free education came into force. Mr Loveband suggested that the two pence should still be sent and a penny bank was started. In support of this he started "The Managers of the school will be the trustees of the bank and be responsible for all money paid into it and as the system is now pretty general the parents should not be loth to encourage the children to lay by for a rainy day and to start habits of thrift. The

savings may be withdrawn at any time giving one week's notice and should the parents be determined to allow the children to save, through a Joint investment with the Post Office Savings Bank, the usual interest will add to their little investments, let us hope investments that will in some instances be the nucleus of a future fortune.'

DID YOU KNOW?
Elizabeth Fry (1780–1845), Quaker and prison reformer, could once be found on the reverse of the English £5 note.

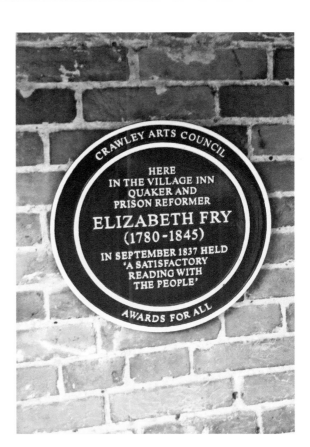

Elizabeth Fry's blue plaque on a cottage, one of the many blue plaques in this area.

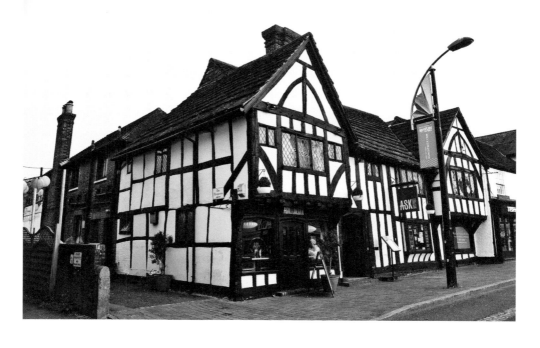

Above and left: Ancient Priors.

6. The Coming of the Railways

During the 1800s towns and villages up and down the country were being linked like never before. For the first time people were able to travel in comfort and at relative speed when compared with stagecoaches. The railways had arrived in the 1840s and brought with it increased trade and prosperity to towns like Crawley, which benefited from being halfway between London and the coastal town of Brighton in East Sussex. It was the Prince Regent who discovered Brighton and felt that Crawley was an idea spot to take a break from the journey, which resulted in the town rapidly expanding to meet the needs and of the surge in population.

Three Bridges station was formerly known as East Crawley and was opened in 1841. The name Crawley has its roots in the Saxon who settled here, naming the area Crow's Leah, which means a 'crow-infested clearing'. Estate and land sellers and auctioneers were able to advertise properties as being within the proximity of the London to Brighton railway line and described in great detail that some trains took one and a half hours to travel the distance whereas if you travelled first class you could be back in the city within forty-five minutes.

It was not just the positive impact that the railway had on the area of Crawley but also the fact that the railways allowed people from London to travel this relatively short distance to experience the countryside and all its charms. There is a short extract from the *Pall Mall Gazette*, which wonderfully describes part of an itinerary for a cycle tour:

Pall Mall Gazette – Saturday 23rd September 1893 – Cycle Rides Round Town On the Surrey and Sussex Borders

Three Bridges is a convenient station on the Brighton and South Coast line from which to set forth upon the cycle tour of combined highways and byways. Within the compass of the itinerary will be found much that is characteristic of the Wealden district that lies on either side of the border line of Surrey and Sussex and many remote places, hidden away from the world, whose very existence if utterly unsuspected by the constant traveller by rail between London and Brighton. A level country lane leads from Three Bridges Station to Crawley a pleasant old-world village on the old coaching highway to Brighton which we will cross, and plunge immediately into the wilds along a rustic lane leading to Ifield.

A charming description of a gentler way of life; you can only imagine what the travellers felt like as they embarked on their first adventure in this area and came face to face with the sites and smells of the countryside, so different from their city life.

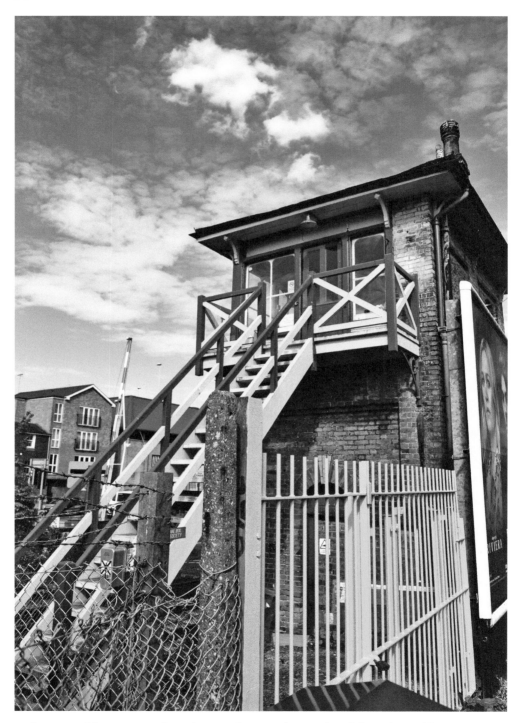

Railway signal box I in Crawley, a historical gem and reminder of the industrial heritage of this area.

DID YOU KNOW?
Three Bridges station was the gateway to the four great estates of the area: Crabbet Park, Worth Park, Tilgate Park and Buchan Park.

With the creation of the Gatwick Racecourse came the question of transporting the horses to the races and this was resolved by providing specially designed carriages for the horses on the trains and at the station so that they could travel safely and comfortably and allow the horses to enter the racecourse easily. It is not hard to imagine that some people have reported hearing the sounds of horses' hooves in the area of the present railway today, yet no one has seen horses or anything that would account for this sound. Many say these are the spirits of the horses who arrived by train to the racecourse for the very prestigious races.

Railways hold a charm and a romance from their humble beginnings, which are often sadly lost today. People would view the railway as a means of status and would dress up in their best clothes and take the whole family with them on a trip. The railway at Gatwick was also used by the racegoers from the city of London. To be able to travel on the railway was held in high regard. Today the railway is viewed as a way of getting around in this country; however, they are still hugely popular and enjoyed by enthusiasts and many tales exist today of ghosts haunting the railways.

DID YOU KNOW?
Gatwick Racecourse had its own railway station where horses could arrive in specially designed boxes straight onto the racecourse.

A gentleman who used to travel on the train from London to Crawley on a regular basis told me of an intriguing experience he had a few years ago. His wife had sadly passed away and he was travelling on his own for business. It was a journey he had made several times with his wife, but never on his own. It was not a particularly long journey, but long enough for you to drift off in thought, as he so often did, now that he was on his own. They had had a very happy life together and had travelled on the trains frequently since their marriage in the 1960s. So his thoughts were back then, in times of happiness and fun. The carriage on that winter's afternoon was very quiet and he was the only passenger in his part of the train. He recalled feeling very relaxed and peaceful and then, as if by magic, as he considered the reflection of the window opposite him, he saw the reflection of his wife looking as she had all those years ago when they got married. He turned to his left where she would have been sitting, but no one was there; yet looking back at the window the reflection was of her. The figure spoke, saying 'don't worry, I am fine and I love you'

and then as quickly as she had appeared, she was gone. The gentleman said that it was the most magical thing that had happened as his wife had been killed very suddenly in a car accident and there had been no time to say goodbye because she had died at the site of the accident. Appearing to him as she had made things more final and at least he knew that she was now at peace – it was wonderful. He likes to think that in some little way she still lingers on in her spirit form on the train where they spent so many happy times.

Three Bridges railway station is named after the village of Three Bridges, which is now a district of Crawley.

7. Villages and Churches

Around Crawley in hidden and secret villages you will find beautiful churches dotted in the countryside, each with their own unique story to tell. In the district you will also find over 110 listed buildings, which are made up of places of worship and farms. There are also a few buildings of special interest including the signal box, the watermill and the Beehive. However, I would like to share with you some of the beautiful and secret churches in the surrounds, often forgotten about in the quiet corners of this area that is dominated by the airport.

St Michael and All Angels Church was built by the Gothic Revival architect William Burges. This is the only remaining building from the former village before the airport existed.

Every other structure in the village was demolished apart from this church.

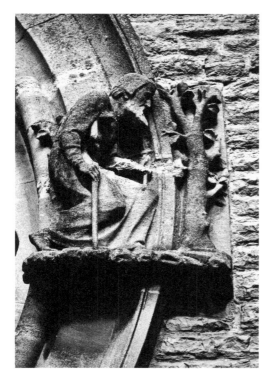

The architect also worked on the Great Exhibition in London.

The church is considered to be an architectural highlight.

The church is built in the Gothic style using stone from nearby St Leonard's Forest.

Carved panels depicting the four ages of man can be found within the church.

Worth

St Nicholas' Church in Worth is a beautiful example of a Saxon church, built over 1,000 years ago and is by far the oldest building in Crawley. Archaeologist's have dated 95 per cent of Worth to before the eleventh century. It is said that the church was built by Edward the Confessor, who enjoyed hunting in the nearby woods. There is still some original work inside the church including the nave walls, the three magnificent arches and the two transepts. The church itself offers peace and tranquillity from the hectic life and noisy roads which surround this area. One aspect that dominates the church are the three great Saxon crossing arches. The design of the church itself is quite unusual for the period, being tall and wide in structure. Some changes were made in the thirteenth century to the layout and restoration work took place in 1871 and after a fire in 1986, which destroyed parts of the old building. One interesting feature here is the Lychgate, which was created in the seventeenth century at the church entrance. The roof is made of Horsham stone and the body is timber arranged into arch formations on each side. It was vastly rebuilt in 1956.

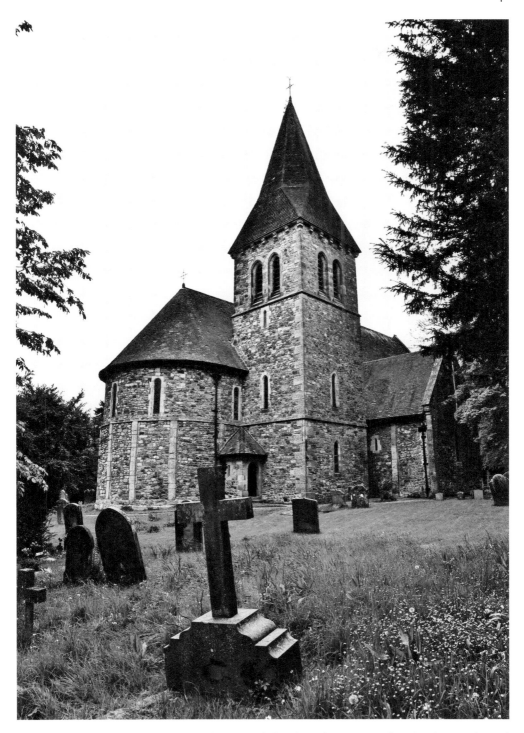

Over the centuries St Nicholas' Church has provided a place of sanctuary. There has been a place of worship here for over 1,000 years.

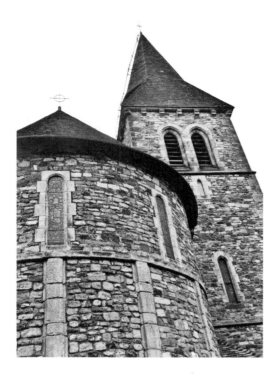

Parts of St Nicholas' date back to 950 and 1050, in particular the chancel arch and apse.

Originally the church was built on forest ground.

The beautiful lychgate at St Nicholas'
Church, Worth.

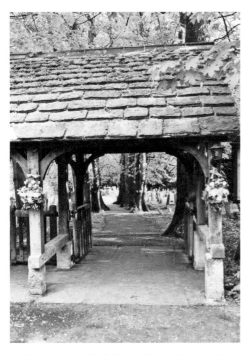

Lychgates provided shelter from the rain during a burial service.

Ifield

Ifield is mentioned in the Domesday book as 'Ifelt', which means 'open land where the yew trees grew'. The church that lays in Ifield is a treasure trove. It has been there for around 770 years and outside its walls sleeps the famous man who edited *Punch*, Mark Lemon, who lies in a simple grave. An oak and yew casting their shadow over him. He was born in London at a time when houses graced the area and he was brought up on a farm by his grandfather as his own father was ill. He started off in journalism on *The Field* and then *Punch*, for which he was the first editor at 30 shillings a week. For twenty-nine years he edited the successful magazine, saving it from disaster in the early days by using the money he made from his plays, and when he died, still its editor, it had established itself as the most famous and dignified humorous journal in the world. Here you will also find the ornate gilded lions and crowns that came from the House of Commons, St Margaret's Church, Westminster.

DID YOU KNOW?
St Nicholas' Church at Worth was built by Edward the Confessor.

Looking down on the church is a dove. It is in the middle of a beam above the sanctuary and has been there for around 650 years. It is as old as the two chief possessions of Ifield, which are the stone figures of a knight and a lady, lying with the nave between them as they have been for over 600 years. The village carpenters created the lectern, the craftsmanship for which excellent, especially those of the ancient coffin plate inscriptions.

In the graveyard you will find a Hindu woman resting. She came to the area at the age of ten from Bengal and worked as a servant in the Capper family for seventy-seven years until she passed away. The timber porch has been there for around 750 years and is made from part of the altar rails. There is also a grand table tomb in the graveyard, raised on a plinth, which has an oval-shaped projection in decoration that is typical of the work of Robert Adam. There are inscriptions dedicated to George and Mary Hutchinson, who were buried here after their deaths in the late eighteenth century. On the top of the structure is an impressive urn.

DID YOU KNOW?
A dove is carved into a beam at Ifield church and watches over visitors.

A story that has its roots in medieval Ifield is to do with crime and punishment. During this period crime was punishable by torture and by humiliating the wrongdoer, which

The Church. Ifield

Ifield's magnificent church – a secret sanctuary.

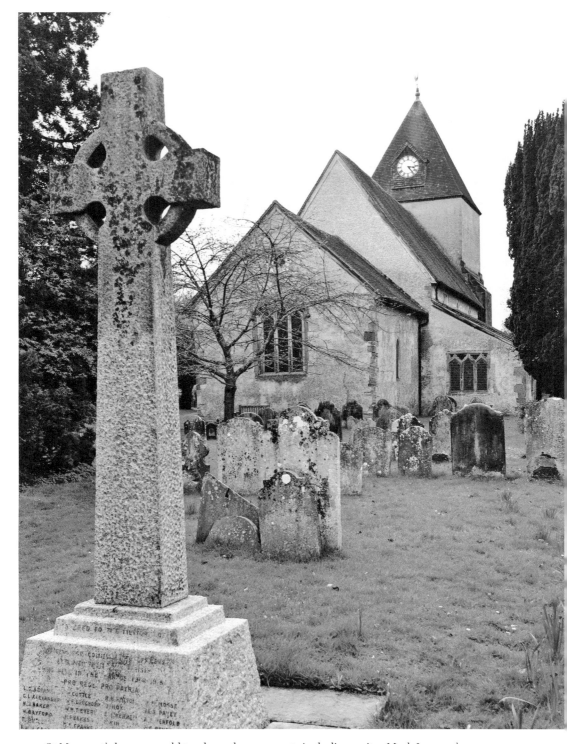

St Margaret's has many old tombs and monuments including writer Mark Lemons' grave.

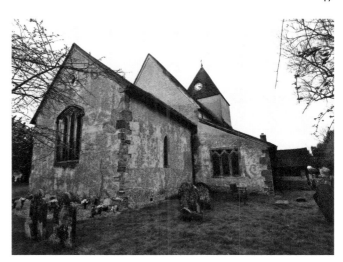

St Margaret's, Ifield, dates from the thirteenth and fourteenth century.

was often enough to make them not commit any such crime again. Popular punishments were the stocks and the ducking stool. Also for persistent criminals, public execution by hanging was the only means of punishment. Public execution was mainly carried out for such crimes as assisting smugglers with their work and murder. Public hangings brought out the whole family – it really was a public event. People would have brought along their picnic lunch and ale and the whole family and made an event out of someone's execution. These usually took place in the centre of a small town or village such as Ifield so that many of the residents in the area could witness the execution and therefore be put off doing any wrong themselves.

Another popular form of punishment was to be hanged on the edge of the town or village while you were still living – again this is said to have happened in the villages around Ifield. You were left to hang until almost dead and then left for the devil and his birds to peck out your eyes and finish you off. One such site was on the edge of Ifield close to the forest area, which saw many a merry execution take place. Today the area could be mistaken for any other village but long ago criminals would have been hung here for days wishing for death. It is not surprising then that strange wailing sounds are heard in the middle of the night and an odd stillness can also be felt in the air.

St John the Baptist Church, Crawley

St John the Baptist Church in the centre of Crawley is charmingly set among the old streets and several other buildings that date from twelfth century (the Prior's House and the Punch Bowl). The church itself dates from the fourteenth and fifteenth centuries and has a massive tower, which is rare for Sussex churches. On the west wall you will find some strange stone figures: a sedate little fellow at the bottom, an amusing little man slightly above him and a larger figure on top. The church is home to some quaint carvings, both in stone and wood and built into the chancel arch, that are decorated fragments of three stone canopies dug up in the churchyard. They may be as old as the fourteenth century, and are a very unusual type set up on two round steps.

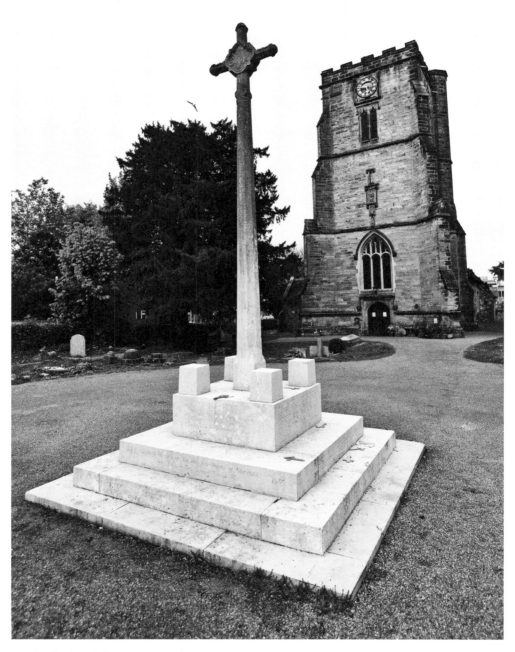

St John the Baptist's war memorial.

If you look carefully enough you will see the tiny hole carved in the pulpit, which was made by the person who did much good work for the church. He carved the choir stalls and the reading desk. It was this parson craftsman who cut the hole in the pulpit. There is another piece of wisdom on the beautiful oak roof built when the church was remodelling in the fifteenth century. It is decorated with golden letters on a very fine beam and says in Old English:

> Man in wele bewar for warmly good makyth man blynde,
> Bewar before whate cumyth behynde.

Of interest there is also a brass of an unknown lady, which has been there for over 500 years. She is thought to have been of the Culpepper family. I am sure that you will agree that this church and its grounds are a beautiful area to enjoy.

As well as the church there is also the rectory close by, which was built in 1830 and interestingly does not appear to have been built to replace an earlier one. The building is designed classical style with Doric columns at the entrance porch, grand windows and a conservatory. A short distance away in the village you will also find the vicarage, which also dates back to the early seventeenth century and was altered in the nineteenth century. It is grand and has stuccoed brick and a Welsh slate roof.

In the area known as Langley Green you will find the Friends Meeting House established by the Quaker community in Ifield in the mid-seventeenth century. By 1676 when the meeting house was built more than a quarter of the residents were Nonconformists. The building has been continuously used for worship and is one of the oldest purpose-built Quaker meeting houses in existence today. Here you will also find some mounting blocks that were used to help riders mount their horses. This one was provided to help worshippers of the Friends Meeting House in the eighteenth century.

Rusper

Venture some 4 or so miles from Crawley and you will find the village of Rusper, which has many beautiful half-timbered buildings. Rusper was formed around the twelfth-century Benedictine priory, when the name Rusper is recorded. Many buildings in the village date from the sixteenth and seventeenth century including the L-shaped Avery's and Sweet Briar on the west side of the street, The Plough Inn on the east side and the Star Inn. The name Rusper is quite unique to England and no other place has a similar sounding name. There are some who think that its derived from the Old English 'ruh spaer', which means 'rough enclosure'. In this is a magnificent church that was founded around 1200, although many changes have happened throughout the nineteenth century, leaving little behind of its original roots. From the height of the church tower you can see all the riches of the lands around. At the foot of the tower you will find the graves of five women who were the prioress and four nuns from the priory that stood for centuries a mile away from the church. They slept in the ruins of the nunnery for at least 300 years. In the middle of the nineteenth century their graves were opened and inside among their bones were crucifixes of gold and shining enamelled chalices.

Finely set in the chancel wall are two brasses from the days when the priory was in its glory. One shows John de Kyggesfolde and his wife as they looked in the fourteenth century. She is veiled rather like a bride, and they are the earliest married couple brass in Sussex. The other brass is that of Thomas Challoner and his wife and son.

Left: St John the Baptist Church, Crawley.

Below: Secrets of a paranormal kind lurk in the graveyard of St John the Baptist Church – are you brave enough to visit after dark?

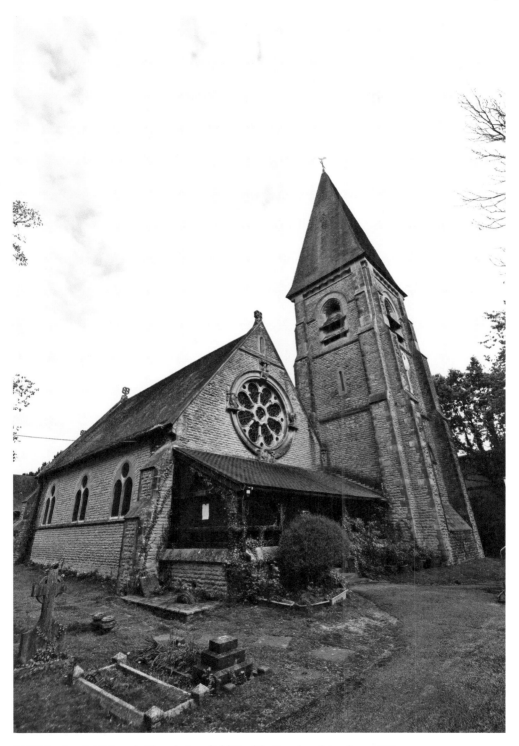

St Michael and All Angels Church, Lowfield Health, Crawley, dates from 1868.

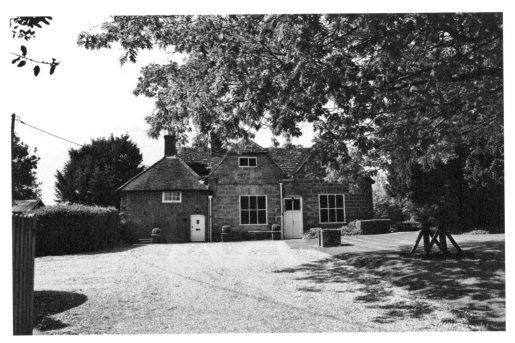

The Friends Meeting House in Crawley was built in 1676 and has been used since then by the Quaker community.

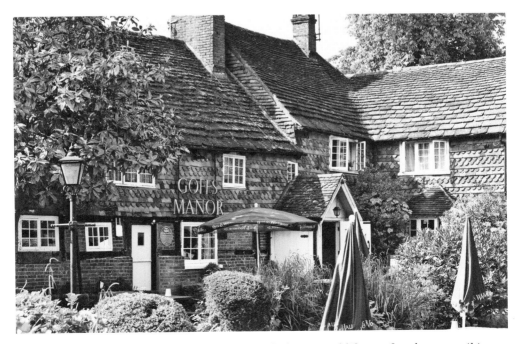

Goffs Manor, Crawley, is a traditional country pub that started life as a farmhouse until it was converted into a pub in the 1930s.

8. Horse Racing and Other Sports

Crabbet Park

If you venture behind the Holiday Inn on the M23 you will find an old country mansion in what used to be known as Crabbet Park – this itself has a very secret and colourful history. It was built in 1873 and was designed by Lady Anne Blunt, the granddaughter of Lord Byron, and her husband Wilifred Scawen Blunt, who led a secretive double life (or so he thought). This house was the venue of the famous Crabbet Club, welcoming royalty, politicians of the day and the most prominent people of early twentieth-century society. The Crabbet Stud was also located here and was world renowned for being the first stud in the country to import and breed Arab horses. Wilfred and Lady Blunt shared a deep passion for horse. However, this was all they shared, eventually divorcing, with the stud being left to their daughter, Lady Wentworth. Sadly she passed away in 1957 and the beautiful house was converted into flats.

An article from the *Illustrated Sporting and Dramatic News*, dated 16 July 1898, describes the annual auction sale at Crabbet Park:

> Auction Sale at Crabbet Park – Arabian Stud Farm
>
> The annual sale of Arab horses is announced to take place at Crabbet Park on the usual 'Saturday before Goodwood', July 23rd and a full gathering of those interested in the desert horse may be expected, as well as Lady Anne Blunts invited guests in the luncheon tent before the auction. This is now one of the principal annual events in Sussex and special trains will be run from London Victoria to carry down the London Visitors to Three Bridges Station during the forenoon.

Gatwick Racecourse

Many people have asked me while I have been doing this research, 'So how did Gatwick get its name?' Well that goes way back in time. The area we know as Gatwick today has had settlers there from as early as 5000 BC. In the thirteenth century John de Gatewyk owned some of the land, which was used for agriculture, and this stayed in his family for over 450 years. The Jordan family purchased the manor of Gatwick in 1696 and the family constructed a large new house to replace the old manor. This was located at Povey Cross and wasn't demolished until 1950 and this area is now what makes up part of North Terminal.

DID YOU KNOW?
Gatwick racecourse was the only other place to have held the Grand National.

As you read this history relating to what was there before the airport, its quite hard to imagine the huge changes this area has been through. However, what I find more amazing than anything else is that it once was known as one of the major racecourses in the country! How many people know this fact when they are sat waiting for their flight? So just how did it become a racecourse?

Back in 1871 at a time when people were travelling out of their towns and cities and visiting new places, one place to be seen at was at the races. Croydon has two racecourses – Park Hill and Woodside, which had its very own railway station. While this was great for visitors to the racecourse, it also brought with it its very own problems in the form of unsavoury gangs of visitors from London and so therefore in 1890 the Mayor of Croydon decided to close Woodside racecourse to bring an end to this unacceptable behaviour that could ruin the reputation of the sport.

Following the closure of Woodside Racecourse the hunt for a new and suitable piece of land began. The Gatwick Racecourse Company, made up of members from the old Croydon Racecourse Company, found some land located beside the London to Brighton railway near Horley. They successfully bought some of the land and construction of the racecourse began.

The railway company built a new railway station to serve the racecourse, which would also have sidings for the horse boxes, enabling the horses to arrive at the race by train. The site of the old station has now been built on and is where you will find the present-day Gatwick Airport station.

In 1891 Gatwick Racecourse was opened and was a huge success with racegoers. By 1900 it was equal to Ascot as one of London's top racecourses. The course was a delight for all, with fine grandstands and paddocks. The following is an article that appeared in the *Sussex Agricultural Express* on Friday 8 May 1891 regarding an inspection of the racecourse:

On Saturday, by invitation of the managers of this important undertaking, a numerous company of racing men and gentlemen of the neighbourhood availed themselves of the opportunity to inspect, the racecourse stands, stables etc. A special train left Victoria at 11.30 a.m., calling at Clapham Junction, Croydon and Horley about a mile from which latter station, close to the line the new course is picturesquely situated. The party were accompanied by Mr George Verrall and were met on arrival by his partner, Mr Southam, who has taken Gatwick House. The weather, was included to be showery but it did not in anyway interfere with the visit, which proved a most enjoyable one in every aspect, while all were unanimous on praise of the suitability of the place for the purpose which it is intended namely, a high-class meeting. No expense has been or is being spared to meet every requirement both in the way of accommodation and attraction and it is a

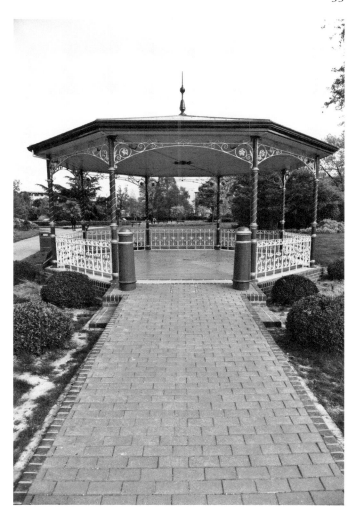

This bandstand was once located at Gatwick Racecourse.

gratifying feature of the enterprise to the promoters that his Royal highness the Prince of Wales has already joined the Gatwick Club. The Brighton Railway Company are erecting a convenient station adjoining the stands, which are very commodious, and when finished will present an exceedingly handsome appearance and indeed will the whole surroundings. The course is considered to be one of the finest in England with a straight mile, second only, perhaps to the Rowley Mile at Newmarket.

The course spanned two miles in distance and race numbers increased from three a year to 16 a number of years later.

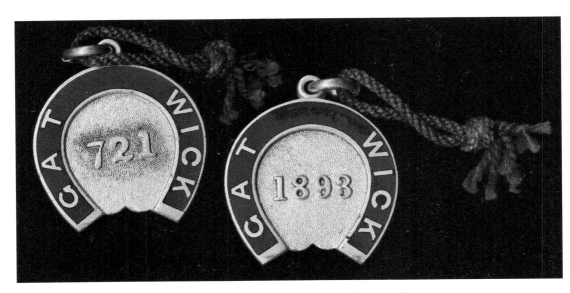

Horse badges from the Gatwick Races. (Courtesy of the Bristish Museum)

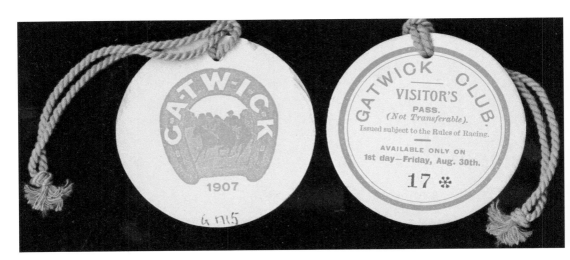

Gatwick Club visitor's pass. (Courtesy of the Bristish Museum)

Gatwick Club member's pass. (Courtesy of the Bristish Museum)

Here is a snippet from 'Racecourse Chat', an article run in the *Scotsman* on 22 January 1916:

Before racing started at Gatwick I walked round the course with the idea of finding out the prospects of the success of the substituted Grand National, which is to take place here two months hence. On arriving back at the stands, I sought out Mr F. H. Cathcart, the clerk of the course and spoke to him regarding certain alterations which seemed necessary. Mr Cathcart answered: The whole of the fences as you see them today are going to be taken down. The steeplechase course over which the steeplechase are racing this afternoon will be done away with and a new steeplechase built. The five-leading executive of the Steeplechase have been invited to assess.

I want you to make clear that all the race meetings during the war are pooled – the profits are pooled and the losses pooled. The decision that it is Gatwick which has been chosen at which to run what is called the corresponding race to the Grand National is because after consideration this was regarded as the most suitable course so far.

The Grand Nationals of 1916, 1917 and 1918 were held at Gatwick as Aintree was requisitioned by the war office. Money made from the races in 1916 and 1917 was kindly donated to the home for soldiers who had tragically lost their sight. Lester Piggots grandfather, Ernie Piggot, won the National at Gatwick in 1918.

There follows an interesting article written for the *Western Mail* in 1921 showing how well-respected Gatwick was as a racecourse:

RACE CHAT – High Class Racing at Gatwick by a special correspondent – Western Mail
21 January 1921

There was some high-class racing on the opening afternoon of Gatwick and despite the rainy morning in town there was a splendid attendance, the rings being packed. Naturally many people were anxious to see Sir James Buchannan's grey colt, Sarchedon, make his first appearance over hurdles in public in the valuable Maiden Hurdle Race. He had some notable opponents among the seven that came out in opposition being the Midshipmite, The Tsar and Be a Lad.

Sarchedon seemed somewhat lusty and in the circumstances the fact that he climbed one or two of his hurdles may be overlooked and I shall expect the colt to do much better at Cheltenham in his next race. Mr Adam Scott won the race with Be a Lad, with Ernie Piggott in the saddle.

The atmosphere at Gatwick on race days was incredible, with the trains from London to Brighton making additional stops at Gatwick Racecourse. The venue itself was hugely popular with visitors, jockeys and owners alike. It was in 1939 and the outbreak of the Second World War that brought an end to the racecourse as it had become to be known.

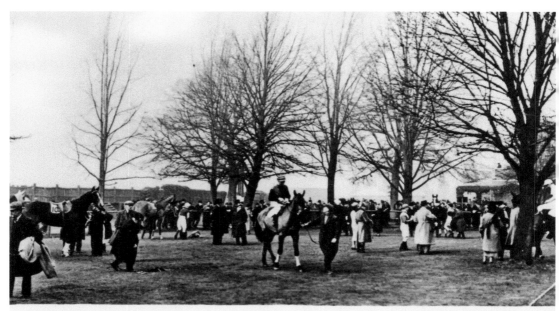

GATWICK RACE-COURSE Inspection in the Paddock COLLECTOR-SPORT
Croydon CR0 1HW

The inspection paddock at Gatwick Racecourse. (Author's collection)

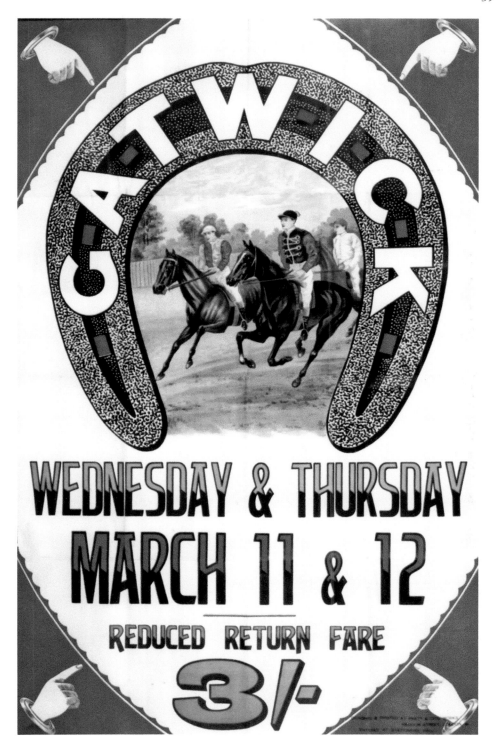

An early advert for the races at Gatwick. (Author's collection)

The Development of the Airport

After the war Croydon was still Britain's main airport and it was here that John Mockford and Ronald Waters first met. The two men had a love of aviation and were both learning to fly, resulting in them going into business together. They set up leisure flights at Penhurst in Kent under the name Home Counties Aircraft Services. Within short time Ronald Waters heard of some land that was available at Gatwick Racecourse and, with help from his father, he purchased 90 acres of the land, which was large enough to run their flying business from. They gained their licences in 1930 and successfully opened their business offering pleasure and stunt flying from Gatwick. The business grew and the Surrey Aero Club was formed. The club included a clubhouse and members could also hire an aircraft and be taught how to fly. Arriving by air was now also an option for the wealthy racegoers.

DID YOU KNOW?
The bandstand in the centre of Crawley once proudly stood at the Gatwick Racecourse.

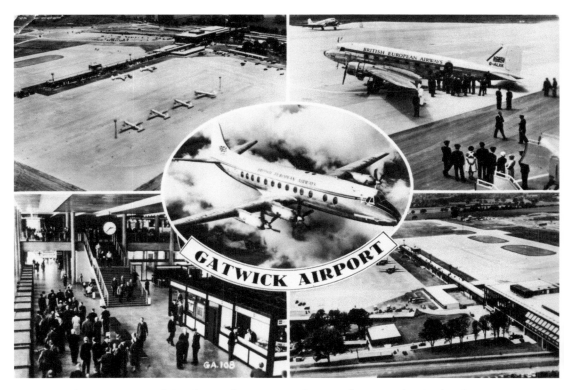

Gatwick Airport postcard dated 1964, showing an early Gatwick Airport. (Author's collection)

The story of how the airport grew from a small partnership to the enormous business that exists today is an incredible one. It was Alfred Charles Morris Jackaman who was set to take it to the next level and had ambitious plans to expand following his purchase in 1929. In 1934, Jackaman succeeded in acquiring a Public Aerodrome license, which meant that Gatwick could now have commercial flights. From then on, many plans and discussions took place between Jackaman and the railway and other interested parties. Plans for passenger terminals were drawn up, with Jackaman's idea being a circular terminal that would be ideal for passengers with covered walkways – which is not that much different to the design of many airports today. Gatwick Airport reopened in 1939 and what we now know as the Beehive Building today was awaiting its first passengers. Gatwick was officially opened in 1936 by the Air Ministry's Lord Swanton.

There follows a short report on the opening of Gatwick Airport, which in 1936 must have been something very special indeed. The article was in most daily and weekly newspapers including the *West Sussex and County Times* of 12 June 1936:

70,000 Attend Airport Opening at Gatwick

From Victoria to Aeroplane in 40 minutes!

London's new airport at Gatwick was opening officially by Viscount Swinton, PC Secretary of State for Air, on Saturday when a crowd of some 70 000-people flocked to examine this terminal air station and witnessed a display of flying by all types of machines.

Gatwick Airport Station is the first airport-rail-terminal in Great Britain and the Southern Railway here made it possible for passengers to travel from Victoria to the post in 40 minutes. There is a covered way to the aerodrome and out to the air liner, thus passengers will be under cover the whole of the journey.

Gatwick Airport has been developed by Airports Ltd with a view to solving the problems of terminal delay for air travellers. The administration buildings are on a novel principle. From the circular outer wall area 6 protruding and covered exists, by which liners may be loaded simultaneously without congestion. A third point about the airport is its situation beyond the Surrey Hills and its general freedom from fog.

I am sure that the building of this new airport must have been very special for the users of it and must have had a very luxurious feel to it, with spacious lounges, a café and a bar for the passengers to relax in.

The first few years were a little tremulous for the airport, which had problems with flooding and airlines pulling out of Gatwick to return to the more favourable Croydon Airport. In 1937 a solution came in the shape of the RAF Training School. However, this was short-lived as on 3 September 1939 war was declared and on 6 September Gatwick was requisitioned by the RAF.

At the end of the war the owners of the Gatwick Racecourse expected things to go back to how they had been and that they would be able to hold their races as before. However, in April 1948 the last ever race meeting was held at Gatwick Racecourse, very visibly minus a large piece of land – many people turned up to watch this point to point meeting.

In 1950 the future of the racecourse and the airport was delayed by the Civil Aviation and so this sadly saw the closure of the racecourse once and for all. This meant that more

land could be bought and developed for the airport and in 1955 there were further plans to develop Gatwick into London's second airport. On 9 June 1958 Gatwick opened as the airport that we know today.

Following the final closure of the Gatwick Racecourse several items found their way into local businesses; for example, there was the weighing chair for the jockeys in the garden of the Lamb Inn for many years and an interesting use of the old betting sheds was that they were used as part of the industrial units in Lowells Lane, which have sadly burned down recently.

The Beehive

As mentioned briefly earlier in this chapter, the Beehive was a unique design for a passenger terminal given its circular shape. When it was built it was described as a good example of 1930s trends where concrete was used instead of steelwork as the main material for buildings to give a modern impression. It was designed so that there was a subway linking the terminal with the railway station so that passengers could always remain under cover. Today the building is a managed office space but still retains all the style and design that it had in the 1930s when it was an iconic building of the time.

Golf and Cricket

Cricket has always been a sporting activity associated with the English countryside, played on a Sunday afternoon on the village green with the ladies making cucumber sandwiches and serving tea at the break. However, the popularity of cricket in the village of Ifield seemed to dwindle somewhat in 1930, as reported in a local newspaper at the time thought to be the *Crawley Observer*.

> Village Lads Prefer Golf
>
> Cricket club can't get players
>
> A crisis faces Ifield (Sussex) village cricket club, which was founded in 1804 and is one of the oldest in Britain. The villagers wont play because they are too busy trying to improve their golf. Mr A. Roberts, Secretary of the Cricket Club declares 'The village lads walked out on us en bloc, so this season when the cricket team turns out on the green, where the game has been played every summer for 135 years, most of the players will be men how may live in the district but travel to London every day.' Mr J. Groam, Clubs Treasurer, said 'I doubt there are more than three members who can call themselves the villagers, the village lads prefer golf to cricket. I think one of the reasons is that they cannot very often get a game of cricket, whereas they can always get to play golf.'
>
> One villager commended 'I prefer cricket there are though many in the village that have given up cricket, many of the older villagers deplore the trend and the club is nothing to what it was ten years ago, says Mr Wood the village bootmaker who has umpired on Ifield Green since 1912'.

Marbles Championship

In a quiet country pub in a hidden location you will find The Greyhound at Tinsley Green. The World Marble Championships were started in 1932, but have their roots back in

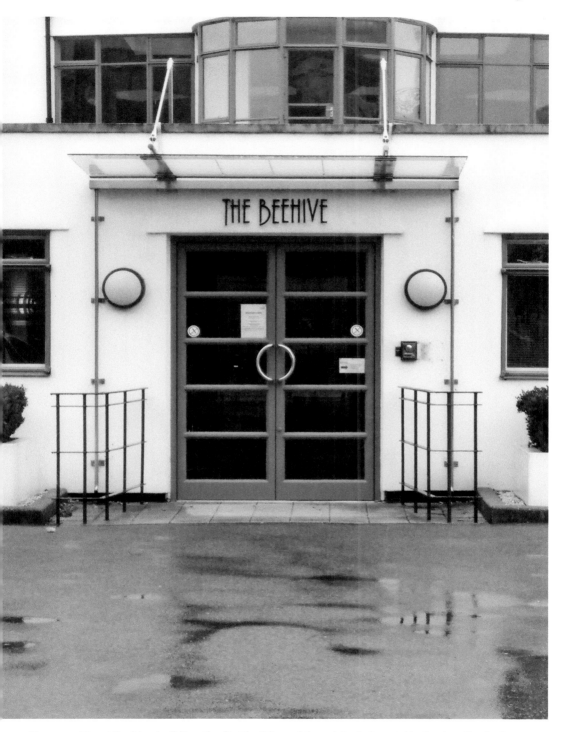

The magnificent Beehive building, the first building of the original airport. (Author's collection)

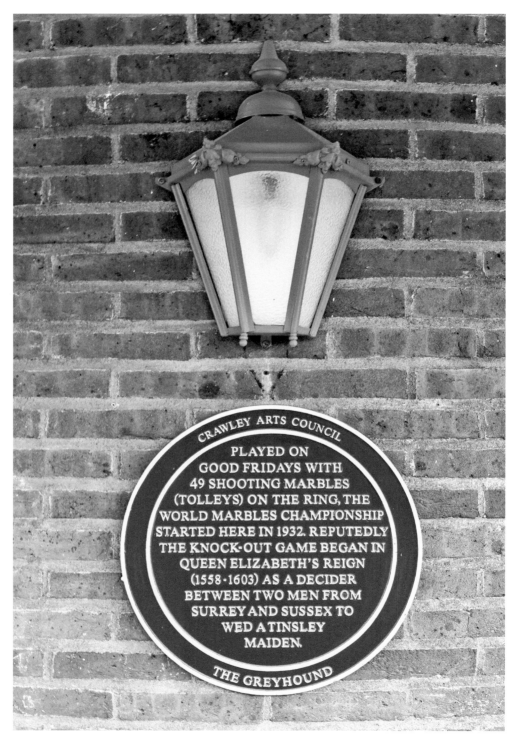

CRAWLEY ARTS COUNCIL

PLAYED ON
GOOD FRIDAYS WITH
49 SHOOTING MARBLES
(TOLLEYS) ON THE RING, THE
WORLD MARBLES CHAMPIONSHIP
STARTED HERE IN 1932. REPUTEDLY
THE KNOCK-OUT GAME BEGAN IN
QUEEN ELIZABETH'S REIGN
(1558-1603) AS A DECIDER
BETWEEN TWO MEN FROM
SURREY AND SUSSEX TO
WED A TINSLEY
MAIDEN.

THE GREYHOUND

Blue plaque at The Greyhound inn, Tinsley Green.

Elizabeth I's reign (1558–1602) as a decider between a man from Sussex and a man from Surrey to decide who should marry a Tinsley maiden. These championships still continue to this day and are very much part of the village community.

DID YOU KNOW?
It is said that the game of 'stallball' was invented in Crawley.

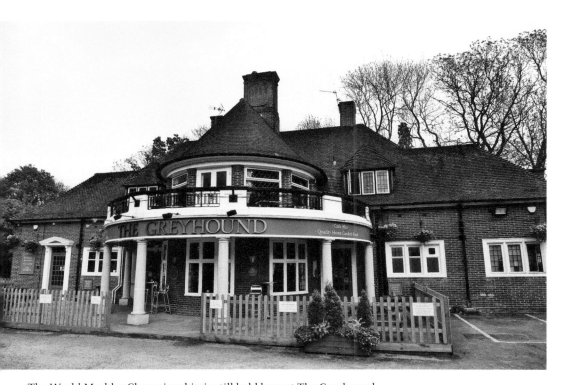

The World Marbles Championship is still held here at The Greyhound.

9. Crawley Trade and Business

The town of Crawley in West Sussex, close to the coast and the city of London, has been a market town since the thirteenth century when it was decided in 1202 that the town was large enough to support a regular market. In 1271 a charter was granted to hold a market and a fair. The width of the high street would give a clue to the town's historic market heritage today and up until the twentieth century buildings were located in the middle of the high street, again pointing to its trading roots. It also has close links to several villages in the Weald. The original spelling of the town in 1203 was Craulei, followed by Crawele in 1250, Croule in 1279 and Crawley in 1316. Crawley would have had many craftsmen such as bakers, blacksmiths and carpenters but early on it was mainly an agricultural area. The men of the families would have worked the land and sold produce such as food and livestock at the fairs and markets. Crawley was situated on the major route between the city of London and the south coast towns and this in itself brought trade and businesses prospered as a result. Crawley had many coaching inns – some still in existence today as inns and hotels. Before the railways arrived linking the capital with towns in the south the stagecoach was a means of getting from a to b and for trading. This history has lingered on and there have been reports of a phantom stagecoach in the High Street. The last fair to be held in Crawley was in 1924. However, things had to change with the increase of traffic to the area.

The new town of Crawley recently celebrated its seventieth birthday and is one of eight new towns that were created outside of London in the late 1940s. The idea was to try to get people to move out of the city of London, which was vastly overcrowded, into the countryside. Much of the housing stock in London following the Second World War was almost slum condition and so this was another reason for tempting people away from the capital, into the clean air and new accommodation in new towns such as Crawley. The other towns were Basildon, Bracknell, Harlow, Hatfield, Hemel Hempstead, Stevenage and Welwyn Garden City. These new towns were the ultimate alternative to the mass overcrowding of the city of London, offering an end to the commute, local employment, decent housing and a clean environment to live. The idea was that new industries would be attracted to the towns to set down roots and prosper, providing jobs for the local people. Many Londoners grabbed these opportunities with both hands as they saw the potential not only for themselves to learn new skills and be working in new environments but also for their children too.

The original plan was to join together the villages of Three Bridges, Ifield and the market town of Crawley by building in between them. Three Bridge represented the typical community that grew up around a railway junction; Ifield, on the other hand, was a rural agricultural village and Crawley had its roots in the 1600s and the coaching inn trade. The area in question measured some 6,000 acres, covering over 3 miles from border to border. The town planners had the idea that non-residential neighbourhoods would work well, each one based on the typical village, grouped around a town with industrial

Crawley grew into a small market town from the thirteenth century.

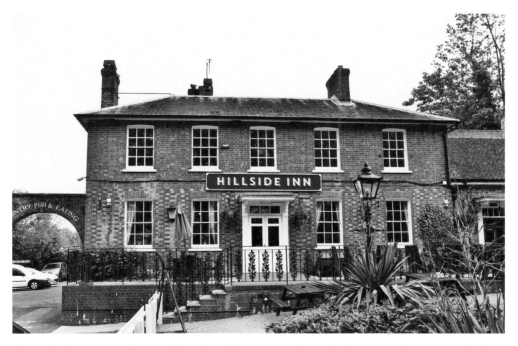

The Hillside Inn, one of many old pubs in the area, was formerly known as the Kings Head when many guests were coach travellers. The inn was ideally located as a suitable stopping point between Brighton and London.

The Ancient Priors, Crawley. (Author's collection)

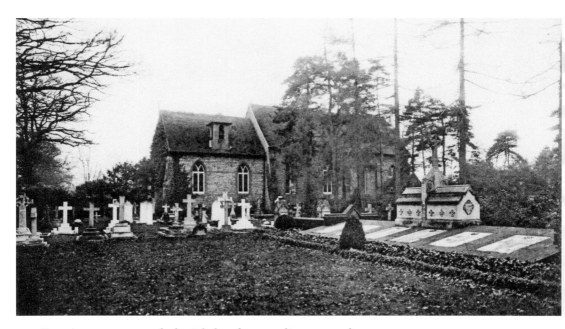

Franciscan monastery, the burial place for many literary people.

areas. Housing would be based on three- and four-bedroom properties with a few larger properties also. The plan was for each neighbourhood to have the same amenities yet still have its own unique character while providing most day-to-day needs for the residents in the form of a church, community centre and public house.

The ideas and plans were indeed ambitious and to ensure things went as they should the government set about appointing development corporations to take the ideas forward in each area. The New Towns Act therefore came into play following ministerial approval. Once a new towns development was complete the development corporation would end. For Crawley this stage happened in 1962, with it further expanding in 1983 to the M23 and a new development to the west. And that is how the new town of Crawley began. I have learnt so much about this place and the significant events in its history, which I would never have known about if I hadn't dug just a little deeper to reveal its secret history.

The George Hotel (Ramada Crawley Gatwick)

The George Hotel, Crawley, is a grand property. Today it is a hotel surrounded by the hustle and bustle of the high street, but this once used to be one of the busiest coaching inns in Crawley. It is known that a building called the George had stood on this site since at least the sixteenth century. The building today is constructed in three parts and sadly nothing of the exterior is original; however, most of the interior has been dated to 1615. The first mention of The George was in 1579 when a local landowner by the name of Richard Covert passed away and gave the area of land to his son. The building was in a valuable area of the town on the west side of the High Street. A timber-framed extension was built,

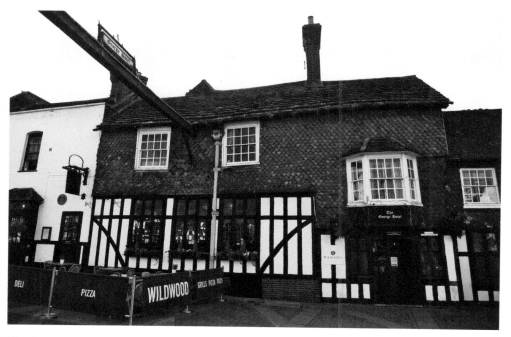

The George Inn is haunted by horse and coaches who vanished in the fog one night.

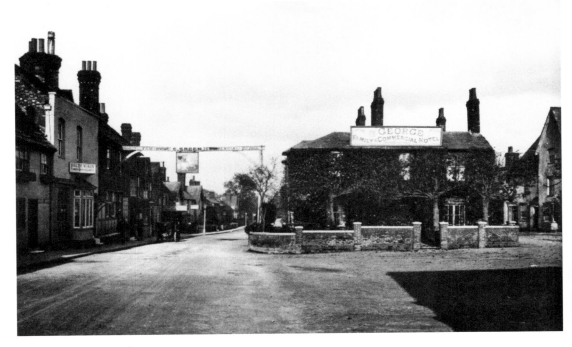

The George Hotel.

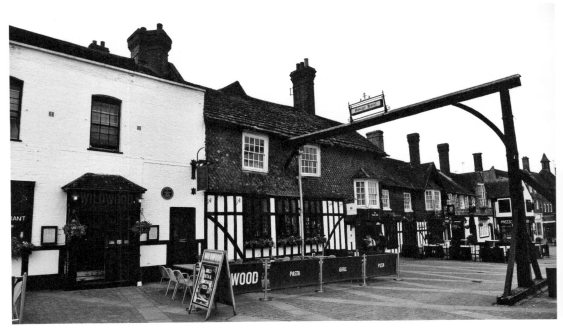

Crawley High Street is home to many beautiful and ancient buildings – look up and you will see them.

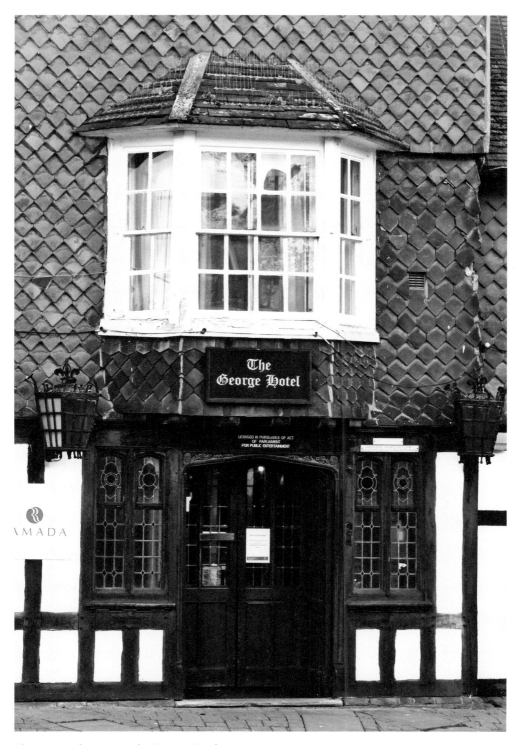

The ancient doorway at the George Hotel.

The White Hart, Crawley, is an eighteenth-century coaching inn and Grade II listed building. It also served as Crawley's central post office during the nineteenth century.

which included a stone fireplace. The inn expanded over the years to accommodate the vast amounts of guests using this inn as one of many on the coaching routes from London to the coast. Major changes took place here in the 1930s.

The 1800s saw Crawley grow and towards the end of the century as Brighton started to develop as a seaside resort so did the numbers of people heading to the coast. The coaching inn you see here would have been quite different than what you see today, with people and packages destined for destinations such as Brighton to the south and London to the north.

It is said that in February 1803, a coach was preparing to leave Crawley late one night. On board were some legal documents that needed to be delivered to London urgently. The driver received strict instructions that he was to head for an exact address and not to stop for anyone or anything. The coach was loaded up and ready to leave Crawley when the head coachman appeared and ordered his driver not to set out as there was strange weather hanging over the town and the surrounding countryside. He was worried that his men would get lost in the mist. People thought that the weather was unlike anything that had ever been seen before. However, the coachman whose job it was to go to London disobeyed his employer's orders and decided to head off, despite the head coachman begging him to stay in the town and set off at dawn once the weather had cleared. The head coachman did not know that his driver had been offered a hefty bonus if he got the documents to their destination in the given time. Despite all warnings, the coach left Crawley, bound for London.

No one knows what happened to the coachman but he was never seen again. Some think that he was set upon by highwaymen and brutally murdered, the coach and horses stolen. Others think that his mysterious disappearance was caused by that strange, thick mist that was lingering over the town that night and suggested that he was dragged away by demons in the mist. The coachman's disappearance will always remain a mystery.

Often on a cold winter's night, the residents in the High Street will hear horses' hooves galloping up the street. However, when they look out of the window there are no horses to be seen, only a strange and lingering mist. This is said to be the spirit of the coach that disappeared all those years ago, trying to find its way back home but remaining forever lost in the mist.

Road traffic increased during the seventeenth and eighteenth century, which in turn brought about many benefits to the shopkeepers in the High Street. Prior to the Industrial Revolution the main source of revenue was agriculture. However, following this period things changed and goods and services were in higher demand. Due to the dramatic increase in road use from the 1700s they started to fall into disrepair and it was declared that users would need to pay for their upkeep. In the late 1700s turnpikes and toll houses were set up along main roads to set this plan in motion. In Crawley the names of two such toll houses are used in locations around the town today: Northgate and Southgate.

DID YOU KNOW?
The George Inn is still a major part of the annual 'Old Crocks' London to Brighton veteran car run each November.

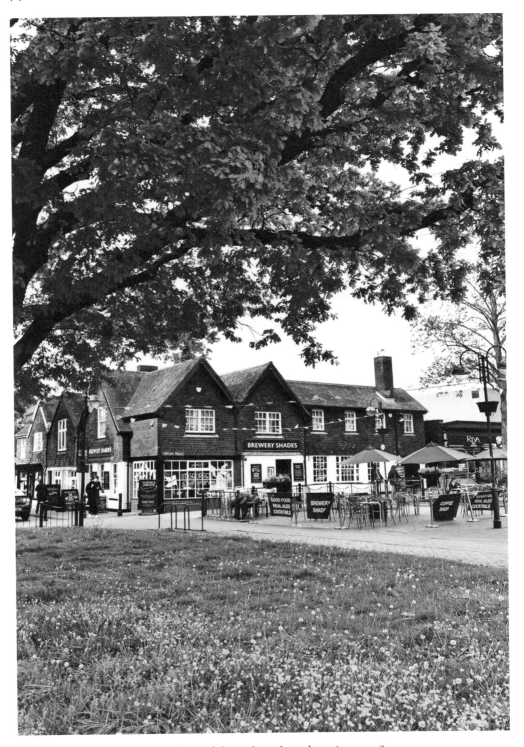

How many customers in the Jubilee Oak know how the pub got its name?

The Jubilee Oak Tree was planted in 1887 to commemorate Queen Victoria's Diamond Jubilee.

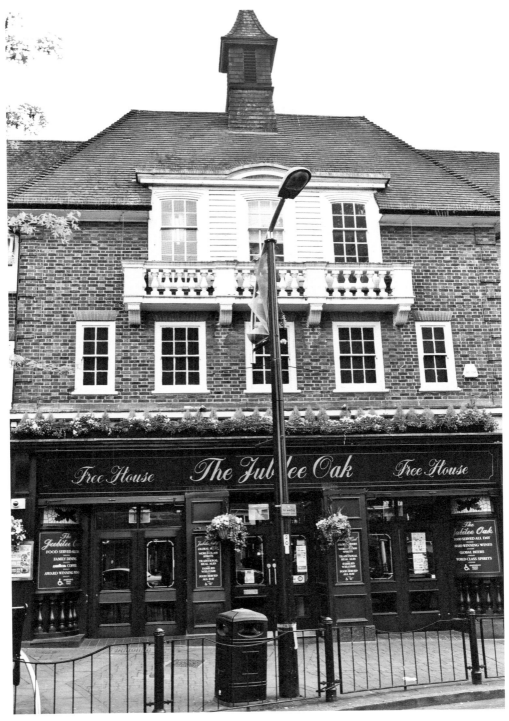

The Jubilee Oak pub was once a building society, taking its name from the oak tree in front of the building.

Stagecoaches from Crawley in 1790 left five or six times a day on the Brighton to London route, which at that time took approximately eight to nine hours. By the 1830s this number had increased to twenty coaches per day and the journey time had reduced to five to six hours.

The Jubilee Oak is a popular pub in the heart of Crawley and is named after the oak tree at the front of the building, which was planted in 1887 by Lord de Blaquiere of Springfield House to commemorate Queen Victoria's Diamond Jubilee visit.

An interesting short report was found in the *Crawley Observer* dated 1940 regarding the sad passing of a Mr Charles Sayers:

> The passing of Mr Charles Sayers recalls a lot of Crawley History as he was born at the Old White Hart Beer house which his parents kept. How long the family lived there is somewhat uncertain, but it was in 1881 that an application was made for a full licence and on this being refused it was decided to give up the beer licence and turn the house into a Temperance Hotel. While structural alterations were taking place a secret room was discovered which had been used by the smugglers of the area. Why they Old White Hart came to be used is difficult to say.

Crawley Museum

In the heart of modern Crawley today you will find The Tree, which is home to Crawley Museum. The new and delightful location is home to many cherished items from the history of the town and area, aiming to show the history of Crawley from earliest times to the present day and The Tree is the perfect location from which to successfully do this. Its position in the High Street means that it has seen the crucial stages of the town's history, from the medieval market through the Victorian expansion with the coming if the railways and up to the bustling modern new town. Inside the Tree there are some very fine timbers, whose tree tings have been dated to 1328. The modern section of the museum houses a temporary exhibition gallery and there are also meetings rooms for hire. It is a lively space and its central location makes it a must for residents and visitors to appreciate the town's heritage. The Crawley Museum Society also runs ifield Watermill. This splendid building looks out over the millpond with all its varied wildlife, and the volunteers who care for the mill often set the waterwheel working. The display inside shows the life of the millers over the centuries, though some visitors prefer to look at the mummified squirrel that was caught in the wall. One of the most evocative objects on display in The Tree is a Bronze Age sword, found in Polestreet Stream during drainage work in 1952. The sword is in excellent condition and probably links to the ancient tradition of throwing objects into water to ask the gods for their help. The largest treasure on display is a Rex Forecar, made in 1903, and for fifty years a regular sight in the London to Brighton Veteran Car Run. It was owned By Ron Shaw, whose family ran a garage on Crawley High Street for several generations.

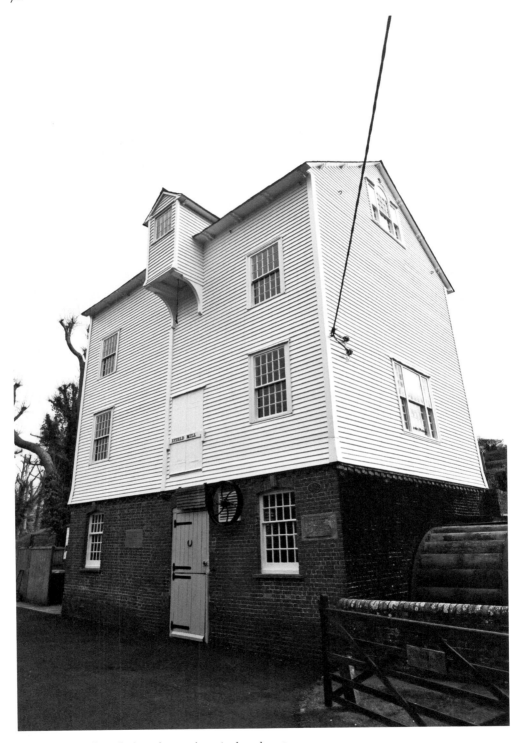

Ifield Watermill is a link to the area's agricultural past.

Right: Ifield Watermill.

Below: Crawley Museum is home to a Bronze Age sword.

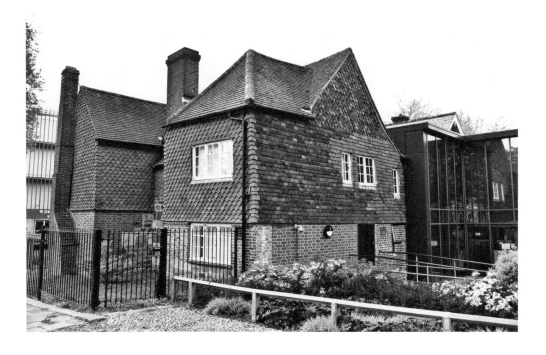

Lowfield Health Windmill is Grade II listed and close to the Surrey–Sussex border.

Lowfield Heath windmill originally dates from 1737.

Shopping Centre

Today Crawley proudly boasts its own shopping centre known as the County Mall, which is home to many high street stores for every taste and budget – everything the modern shopper could wish for in an up-to-date shopping experience. The County Mall is a very popular retail centre for local people and those from further afield travelling to the town, offering a variety of shopping and leisure services. However, it would appear that it is not just shoppers that have been paying the shopping centre a visit, as one security guard told me of the morning when he saw something very strange. It was 4 a.m. and he was just finishing his shift and patrolling the area when he saw what can only be described as the figures of some farm workers crossing from one side of the shopping centre to the other. They looked strange and not as you would expect people to be dressed today as they were wearing old-fashioned tunics and smocks and long shorts. The old-fashioned looking farm workers seemed quite happy and content to be walking 'through' the walls of the stores, with farm equipment and tools in their hands and even whistling as they made their way to work in the early morning. The security guard who had witnessed them was totally amazed at what he had seen and decided that he must see if he could find out any information about what he had seen. The description that he recounted to several people confirmed that, by their style of dress, they were seventeenth- or eighteenth-century farm labourers. This area during that period was rich in farming and so it would not be that strange for there to be spirits from that time lingering on today. This is a fascinating example of two parties of ordinary people from different ages passing each other in a gateway of time.

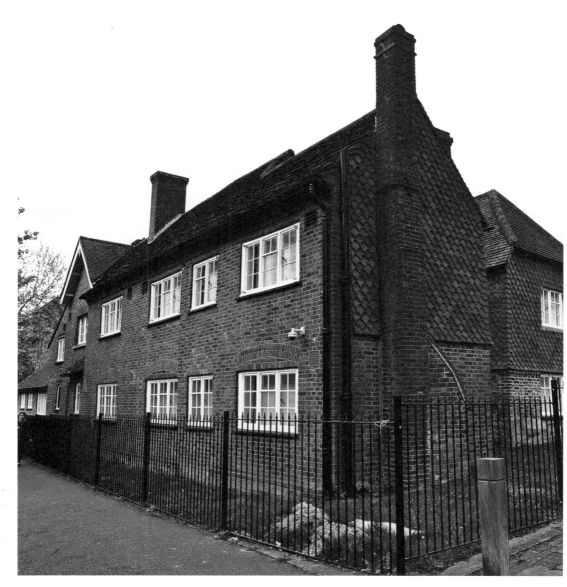

Many buildings in the High Street date back to the fourteenth and fifteenth centuries and offer a glimpse into medieval England.

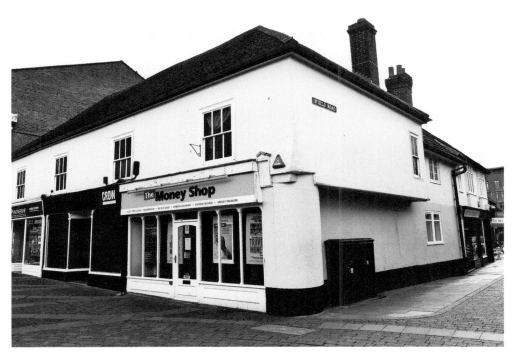

Magical medieval buildings can be found in Crawley High Street.

10. Beautiful Parks and Secret Wildlife

Around the Gatwick and Crawley area there are many green and open spaces, many of which have forgotten histories or places that are seldom visited today. Many have been a significant place connected to substantial wealth in the area and important families, others have a landscape that shows the creativity of their designers and some are home to some of the most amazing wildlife to be found in the area. Beautiful wildlife have made these places their home and each green space offers a different habitat to discover, so spend a few moments and discover the secrets that these tranquil places have to offer.

Tilgate Park

Today Tilgate Park is a large recreational area in the south-east of Crawley. It was originally, however, part of the ancient Worth Forest and has roots back to ancient times. Archaeological evidence has been found dating back to Mesolithic era and arrow heads from around the 8th millennium have been located around the area, which is now a golf course, and these point to the main activity of these lands being agricultural. Moving into the Bronze Age, a round barrow cemetery was discovered in the Pease Pottage area, which is located along the old ridgeway that would have indicated grazing, allowing for viewing across the land.

More recently Tilgate Park was home to a large country estate known as the Tilgate estate. The estate occupied one third of the forest and was owned by Lord Bergavenny until it was sold in 1566 to Sir Walter Covert and Sir Edward Culpepper. By 1865 the estate had changed ownership again, this time to the Sergissons, who expanded the estate, and then on to John Nix. It remained in the Nix family until 1939 when the 2.185 acres were auctioned in seventy-four lots.

The park is home to some very fine trees that owe their origin to the Nix brothers, who were well known as amateur horticulturalists and remodelled the parkland. They had been successful in business in the USA before taking on Tilgate and therefore the numerous American species trees is explained this way. There are also other trees that are considerably older and have survived life in the park including the suquoiadendron giganteum (redwood type)

Early records show that there was originally a house by the bay in the lake but the Nix family pulled this down to make way for the mansion house. The mansion house was described as a spacious and large country house with a magnificent great hall, a study, billiard room, eight bedrooms and many more impressive rooms. From the house great views of the park could be enjoyed. The house was approached by two drives, which were lined with willow trees. An area of the western part of the estate was used for a Canadian army camp during the Second World War.

Today, much of the estate is now encompassed by the Tilgate and Furnace Green neighbourhoods as much of the original mansion has long gone, being demolished in the 1960s by Crawley Town Council.

The Tilgate estate where the furnaces once stood.

Tilgate was first mentioned in thirteenth- and fourteenth-century tax returns.

Tilgate Forest was home to a furnace in the seventeenth century.

Worth Park

Worth Park dates back to medieval times when it was a deer park and part of the Forest of Worth. The Worth Park estate was purchased by Sir Joseph Montefiore in 1850. The Montefiore family were well known for philanthropy and had a passion for education. Joseph's son Francis was responsible for the vast remodelling of the house and gardens in 1880 following his father's death. Worth Park Gardens are known for their extensive design, which includes parkland, formal gardens and terraces. The house and gardens have an interesting history full of mystery and intrigue. The house was known as Milton Mount College, a boarding school for girls, from 1920 to 1960 but the original Victorian mansion was sadly demolished in 1960 and replaced by modern flats built to the same footprint as the old house. Today the only original part is the stable block, which is built in a quadrangle design and once stabled up to twenty-two horses and a coach house. Worth Park and House would have given the appearance of an elegant mansion set in substantial grounds. It was home to a catalogue of ferns. In the grounds there was also a large maze made from yew and this is shown on maps from 1900 onwards. Sadly, this was destroyed to make way for housing development. Another aspect of the garden that is well documented is that of the camellia corridor or walk and this featured highly in Victorian magazines of the 1890s. Worth Park is also famous for their breed of Jersey cows and the luxurious dairy where the cows were milked.

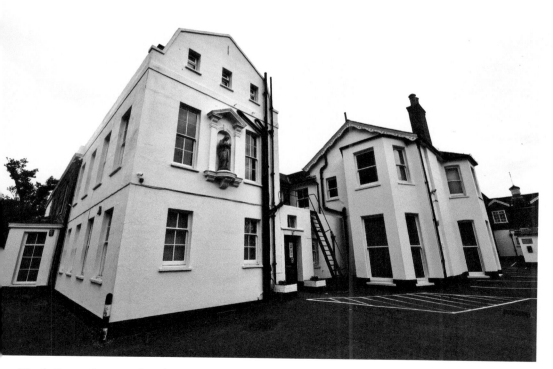

Worth Corner Convent, Crawley. In 1938 it became the convent of Notre Dame private school.

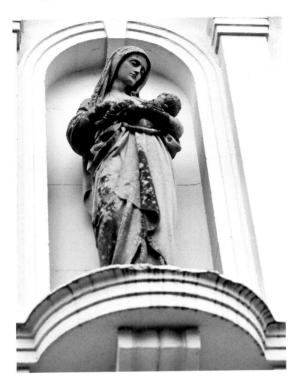

Left and below: Worth Corner Convent.

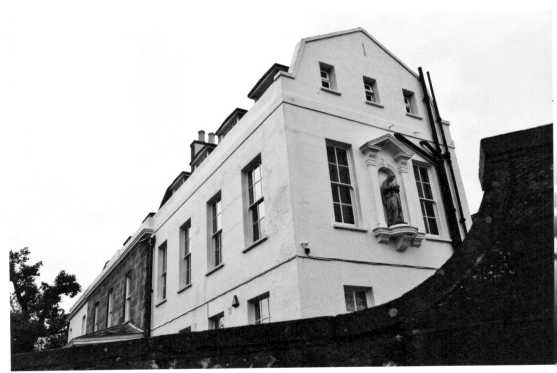

Right and below: Archaeological
finds from Worth Park.

Small plaque from band members to their bandleader Geraldo.

There is a dedicated group of people called the Worth Park History Society who are passionate about keeping the history of Worth Park, the magnificent house and the people who have passed through its doors alive. They hold regular meetings and events to bring history to life and never let this wonderful heritage be forgotten. They are will soon produce their own book on the house and garden full of forgotten secrets. They can be contacted on worthparkhistory@btinternet.com.

Several items of archaeological importance have been found here including a small plaque from band members to their leader Geraldo.

Gratton Park Nature Reserve

In a hidden corner you will find a wonderful sanctuary in the form of Gratton Park Nature Reserve, which is simply bursting with wildlife and offers a retreat from the chaos of daily life. In this quiet corner, consisting of 6 acres, beautiful creatures such as tree creepers and greater spotted woodpeckers have can be found. You will find the River Mole running through this wood, which in itself attracts some wonderful species of wildlife and is an ideal spot to unwind and relax.

Memorial gardens offer a little bit of peace and quiet away from busy daily life.

Wildlife at Gatwick Airport

One of the places you would least expect to find a diverse population of wildlife would be the area that surrounds Gatwick Airport. However, recently the airport has hosted several 'Gatwick Goes Wild' events to bring people closer to the wildlife that inhabit this special place and have made it their home. The events include river walks, bush craft and bat spotting tours. All of this is part of the Greenspace Project to see what can be found on the airport's doorstep and it has proved to be a huge success in highlighting that the airport environment is far more than just about planes and its unique set up supports all number of wildlife. Gatwick Airport invests in protecting and maintaining its environment and the special creatures to whom this is home. Gatwick Greenspace Partnership is a community project that works to benefit people, wildlife and the countryside between Horsham, Crawley, Horley, Reigate and Dorking. The aim of the work of Gatwick Greenspace Project is to inform, educate and involve a diverse range of people from the local communities in the beautiful, natural surroundings. They want to see the local landscape more interconnected for wildlife and so they work with local landowners (including the Forestry Commission, the Wildlife Trusts and the Woodland Trust plus local authorities) to support them in managing their land more sustainably and in partnership with others.

They organise and advise on a range of events and activities including conservation volunteering, landowner advice, guided walks, wildlife encounters, bush craft sessions, Forest School, wildlife gardening and also run sessions for young people looking to work in the conservation industry.

Edolphs Copse

This area can be found north of the airport and forms part of an ancient semi-natural woodland. It is a peaceful and unspoilt sanctuary that offers a home to many species of butterflies, silver wash fritillary and speckled wood. This wood dates back more than 400 years. The copse is mainly secondary woodland but it has areas of ancient forest. You will mainly find oak, hazel and hornbeam here, with a few crab apples and hawthorns. There are also several large ponds and grassland habitats to support the wildlife who have made this their home. This site is owned by the Woodland Trust and is also part of the Gatwick Greenspace Partnership and the Sussex Wildlife Trust. Edolphs Copse remains a relatively peaceful and unspoilt sanctuary for wildlife.

Buchan Country Park

This parkland is some 2 miles from Crawley and is a Site of Nature Conservation Importance (SNCI). Here you will find wooded heath and sweet chestnut coppice, with wet woodlands, lakes and ponds that attract many species of dragonfly, as well as many other species of wildlife. The park consists of 170 acres of beautiful countryside and is recognised as an excellent place for walking and watching wildlife. There are also several sculptures hidden around the park for visitors to enjoy. Here, if you are lucky enough, you can find dragonflies, nightjar, great crested grebe, adder and grass snakes among its diverse mix of habitats. During quiet times roe deer are regularly seen, as well as fox cubs. Bird life is also varied with the birch woods being home to redwing in the winter. Spring welcomes the arrival of visiting chiffchaffs and willow warblers – and did you know that both of these bird species weigh little more than a tea bag! The ponds are home to a rich family of carp and pike.

In the early nineteenth century the park was owned by Lord Erskine, who named the estate Buchan Hill after his father, the Earl of Buchan. Wonderful ancient sweet chestnut trees are a feature in the park. In the medieval times this area was mined for iron ore. There are numerous craters dotted around the woodland and are the remains of mine pits. The meadow area used to be part of Cottesmore golf club but no chemicals have been used on the grass in over thirty-five years. In the summer this is a haven for butterflies and grasshoppers. The area known as Target Hill Health was used as a rifle range in the nineteenth century and the remains of a stop butts lie close to the golf course. In 1823 William Cobbett, a political commentator, rode through Buchan Hill and he described the area as 'two miserable miles' as 'a bare heath with here and there some scrubby birch. It is a most villainous tract'. Today this heath is a valued area for many reptiles and in the month of August the heather turns the hill purple.

In Victorian times the park was owned by Mr Phillipe Saillard, a wealthy French businessman. He acquired his wealth from the sale of playing cards and ostrich feathers for ladies hats. He established island and Duster ponds by damming Duster Brook. Twenty-one species of dragonfly were recorded here in 2016.

Tree Planting in Crawley

In an article found in the *Crawley Observer* of 1941 there is mention of tree planting and how,

There is only one green in Crawley without a tree: Who will be fortunate enough to have the honour of planting the "Peace" tree on this green? When the strong opposition to Crawley's custom of planting trees on historic occasions is remembered. It is curious to hear the former praising the lovely trees on our beautiful Greens. A landmark of Crawley history has disappeared – the old yew tree that stood at the entrance to the squatters cottage in Smalls Lane. What stories of Crawleys past could have been told if that old tree could have spoken.

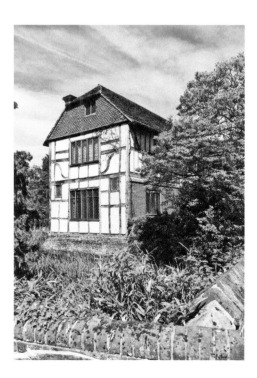

Ewhurst Place.

Bibliography and Acknowledgements

Ward and Locke, *Illustrated Guide to London* (1926)
Jenkins, Simon, *England's Thousand Best Churches* (Penguin, 1999)
Framework Archaeology, Archaeological Evaluation Report (July 2001)

Thanks to Heather Ashby (née Revell) from Horsham for sharing her family's stories with me and to David Thaxter (www.british-caledonian.com) for allowing me to use information from his amazing website. I would also like to thank the Facebook group Memories of Crawley and its members who contributed some wonderful snippets of information about Crawley and the area. Finally thanks to Crawley Museum and Kevin Gravenor.

Every attempt has been made to seek permission for copyright material. However, if I have inadvertently used anything without permission or acknowledgement, I apologise and will make the necessary correction at the first opportunity.

About the Author / Photographer

Tina Brown

Tina Brown was born and brought up in Hastings, East Sussex, and since 1992 has designed, researched and written guided walks of her home town, Rye and other areas in the UK and Bulgaria. Tina has always had a passion for history and for bringing the past to life in an interesting and memorable way. Tina has long believed that if you visit a historic house, castle or ancient town then you should come away asking questions and wanting to know more about the place, the people and the events that have shaped its life. Tina is always looking for new projects and would like to research some new locations; if you have any suggestions please contact her via email at tina@historicexperiences.com. Tina has designed guided tours to accompany this book together with an animated talk. Please contact her if you would like further information.

Andy Hyldon

Andy Hyldon originally studied graphic design but developed a lifelong passion for photography, going on to work his way through the City and Guilds system in the late '90s. He will approach any subject but has a particular love for photographing architecture and also specialises in seascapes and coastal scenes, as well as general travel photography. He also turns his hand to covering music and theatre events, and is the official photographer for the Savvy Theatre Company. He can be contacted by email at andy.hyldon@ntlworld.com.